RAJIV

VIKING

RAJIV

SONIA GANDHI

VIKING

Penguin Books India (P) Ltd., 210 Chiranjiv
Tower, 43 Nehru Place, New Delhi - 110 019,
India

Penguin Books Ltd., 27 Wrights Lane, London
W8 5TZ, U.K.

Penguin Books USA Inc., 375 Hudson Street,
New York, New York 11014, U.S.A.

Penguin Books Australia Ltd., Ringwood, Victoria,
Australia

Penguin Books Canada Ltd., 10 Alcorn Avenue,
Suite 300, Toronto, Ontario M4V3B2, Canada

Penguin Books (NZ) Ltd., 182-190 Wairau Road,
Auckland 10, New Zealand

First Published in VIKING by Penguin Books
India (P) Ltd., 1992

Reprinted 1993, 1994

Copyright © Sonia Gandhi 1992

Editor: Manjulika Dubey

Designer: Priyadarshi Sharma

Photo Editor: Sanjeev Saith

Printed by Acumen Overseas Pte Ltd., Singapore

This book is sold subject to the condition that it
shall not, by way of trade or otherwise, be lent,
resold, hired out, or otherwise circulated without
the publisher's prior written consent in any form
of binding or cover other than that in which it is
published and without a similar condition
including this condition being imposed on the
subsequent purchaser and without limiting the
rights under copyright reserved above; no part of
this publication may be reproduced, stored in or
introduced into a retrieval system, or transmitted
in any form or by any means (electric, electronic,
mechanical, photocopying, recording or other-
wise), without the prior written permission of both
the copyright owner and the above-mentioned
publisher of this book.

ISBN 0-670-84607-4

*For Rahul, for Priyanka,
and for all those who
love and believe in
their father
Rajiv*

CONTENTS

ACKNOWLEDGEMENTS *viii*

AUTHOR'S NOTE *ix*

PROLOGUE *1*

THE LIFE THAT RAJIV CHOSE *17*

THE LIFE THAT CHOSE RAJIV *81*

EPILOGUE: IMAGES BY RAJIV *161*

PHOTO CREDITS *214*

Acknowledgements

Many people have contributed to the making of this book. Rajiv's friends and associates from his youth, from his years in flying and from his life in politics, came forward spontaneously with photographs, written accounts and information. Several of them provided facts or details while the book was being prepared, and some of Rajiv's senior colleagues made time for interviews. I thank them all. I have not been able to make use of all of their material in this book, but it will be treasured in the archives of the Rajiv Gandhi Foundation.

While I have taken care to establish the identity of the photographer of each picture, this has not always been possible. I regret any inadvertent error or omission, and would appreciate it being brought to my notice. Most of the photographers whose work appears in this book have contributed their pictures out of regard and affection for Rajiv; to them I am most grateful.

Several organizations have allowed me access to their photographs and other material. Among them I would like to thank the Nehru Memorial Library, the Indira Gandhi Memorial Trust, Photo Division, Press Information Bureau, *India Today*, the *Ananda Bazar Patrika* group and *Hindustan Times*.

V. George worked with devotion for long hours, providing assistance with research and voluminous data on Rajiv's work schedule. P. P. Madhavan and other members of my staff were willing and helpful in providing secretarial support.

I have drawn gratefully from Dorothy Norman's collection of Indira Gandhi's letters. Simi Garewal very kindly and readily provided transcripts of her interviews with Rajiv. Mani Shankar Aiyar gave of his time freely and was a fund of useful information. Priyadarshi Sharma and Sanjeev Saith contributed their creative talent and time. Anurag Gupta was unfailingly helpful with his computer skills and with other technical support, while Ranesh Ray's final proof-reading and critical comments were invaluable. Amitabh Bachchan provided generous help in getting Rajiv's collection of colour photographs processed. Suman Dubey remained an obliging and supportive friend.

Manjulika Dubey gave me not only her professional expertise as an editor, but her constant and caring presence as well. Throughout these difficult months my mother, my two sisters and all my friends have been a source of strength and encouragement. Most of all I have been sustained by the tender love and the courageous example of my children, Rahul and Priyanka.

Author's Note

This book is neither intended to be a political biography nor an analysis of issues.

It is a sharing of some moments and events in Rajiv's life and the meaning they held for him.

I WAS EIGHTEEN when I arrived in Cambridge on 7 January 1965. I had enrolled at an English language school for foreign students and lived as a paying guest with an English family assigned to me by my school. I was away from home for the first time in my life. Cambridge at that time of year was cold and gloomy. I could not speak or understand much English. I had never eaten boiled cabbage and gooey spaghetti on toast, nor had I ever had to pay to have a bath every day. What on earth had made me want to study in such a strange place? I felt miserable. I missed home terribly and, as most Italians do when they are abroad, I missed Italian cooking. I found out that the only place in Cambridge you could have something close to home food was a Greek restaurant called Varsity. I began to go there regularly for my meals.

I had noticed on a number of occasions a large, noisy group of students usually sitting around a long table opposite mine. One of the boys in that group stood out. He was striking in both looks and manners. He was not as boisterous as the others, he was more reserved, more gentle. He had big, black eyes and a wonderfully innocent and disarming smile.

One day, as I was having my lunch, Christian, a German friend who was fluent in Italian, walked in, followed by the boy I had often noticed. After the usual exchange of pleasantries he introduced me to his friend, Rajiv. As our eyes met for the first time I could feel my heart pounding. We greeted each other and, as far as I was concerned, it was love at first sight. It was for him, too, as he later told me; he had in fact asked Christian earlier to introduce us to each other.

Soon we found that we wanted to be together as much as possible and we spent most of our free time in each other's company. In those days I had a vague idea that India existed somewhere in the world with its snakes, elephants and jungles, but exactly where it was and what it was really all about, I was not sure. I did find out as soon as I got a chance to, from a school friend whose knowledge of geography was a bit better than mine. God, was that where India was — so far away, at the other end of the world!

Life in Cambridge was now easier. I had made many friends. I had a special one in Rajiv, and I no longer missed my home as I used to. As we got to know each other better, Rajiv and I spoke about ourselves, our families, our aspirations. Our families could not have been more different. My father was known only in his restricted provincial milieu as Signor Maino, the owner of a building firm which was doing well in those days of the construction boom in Italy, and as a blunt, straightforward man who had earned each lira he had through sheer grit and hard work. Rajiv's family was known not only to the whole of India but to the world for the political role it had played in India's freedom struggle. I learned from Rajiv that his grandfather, Nehru, had died the year before and that his mother was a minister in the government. Rajiv wrote to her about me and she expressed a wish to meet me on her coming visit to London towards the end of the year. As for myself, I had not been able to muster enough courage to tell my parents about my feelings for a boy who was to them not only a stranger but a foreigner.

The day of Rajiv's mother's arrival in London was approaching. The thought of meeting her terrified me. A time was fixed. Rajiv drove me down from Cambridge, but as we got into town, I panicked. I could not control myself. God knows what she would say or do to me. (The power of a man's mother is not exclusively an Indian phenomenon.) Rajiv tried to calm me down and reassure me but it did not help. He had to make an excuse and cancel the meeting. Another day was fixed and this time I made up my mind that I would behave myself. I met Rajiv's mother in her room at the High Commissioner's residence and drew a sigh of relief

when I found that she was a perfectly normal human being, warm and welcoming. She went out of her way to put me at ease. She spoke to me in French, knowing I was more fluent in it than in English. She wanted to know about myself, my studies. She told me that I need not be frightened because she herself had been young, extremely shy, and in love, and she understood me perfectly.

Rajiv and I were to go on to a students' party that evening. In one of the anterooms I changed into my evening dress. My high heel caught in the hem and tore a bit of it open. Rajiv's mother, in the calm fashion which I was to observe at close quarters later, took out a needle and black thread and proceeded matter-of-factly to stitch up the hem. Wasn't that exactly the sort of thing my own mother would have done? All the small doubts which had remained vanished, for the moment at least.

Rajiv and I were in Cambridge and London together from February 1965 till July 1966, after which I returned home and he started his flying lessons in London. We wrote to each other almost every day we were apart, while he worked to save money to come to Italy. In one of his letters he said, "I am sorry I have not written before but we [he and a friend] had got a job working on a building site as labourers. We had to work 10 hours a day, and going and coming took another one-and-a-half hours and by that time we were quite dead. I am still very stiff and can only write very slowly."

After getting his licence towards the end of November, Rajiv travelled to Italy to talk to my father about his plans. He wanted to go back to India and get himself a commercial pilot's licence and a job so that we could get married. My father had no doubts whatsoever about Rajiv's truthfulness — "One look at his eyes and you know the boy," he said. His doubts were about his daughter: she was too young to know her mind; she could not possibly get used to life in India — such different people and customs. There was no question of his permitting me even a short holiday there till I was of age. However, if after a year of separation Rajiv and I still felt the same for each other, my father would consent to my visiting India "to see for myself", so that I would not blame him later for messing up my life. He was convinced that the whole thing would die out within a few months. But it didn't. He kept his promise and soon after I turned 21 he allowed me to travel to India. On 13 January 1968 I arrived in Delhi. Rajiv was at the airport with his brother and his friend Amit to fetch me. The moment I saw him, I was filled with a tremendous sense of relief. I was by his side now and nothing and nobody was ever going to separate us again.

I STAYED with the Bachchans, old friends of Rajiv's family from Allahabad, till 25 February, our wedding day. Everything around me was new and strange: the colours, the smells, the flavours, the people. Strongest of all were people's eyes — that gaze of curiosity which followed me everywhere. It was an exasperating experience — the total lack of privacy, the compulsion to constantly check myself and repress my feelings.

I felt resentful and kept asking myself why those eyes were so insistent. I was to discover in time that this unnerving stare was not simply because I was a stranger and a foreigner. I was also a new member of a family that had for years lived in the public eye. Everything they did and said, as well as what they didn't say or didn't do, was analyzed and judged. How was it possible to live like this!

My immediate reaction was to retreat. Rajiv and his mother, who both knew what shyness was, understood my feelings. I found some of the customs hard to comprehend. I felt

awkward and uncomfortable wearing Indian clothes. My palate would not accept the unfamiliar pungent flavours of Indian cooking. Neither Rajiv nor my mother-in-law forced these upon me. If she found my hesitations and occasional retreats in any way offensive, she wisely held herself in check, and encouraged me whenever I made an effort on my own. I was allowed to be myself, and to find my own way of fitting into Rajiv's world. I began gradually to take an interest in the running of the household. I started learning Hindi, initially with a tutor at home and later at an institute in Delhi, but I found it easier and more helpful to converse with the family and other members of the household. We generally spoke Hindi around the table.

The sharing of meals was a family tradition going back to Teen Murti House. Regardless of where each member of the family might have been, we would all make it a point — unless an official engagement intervened — to sit down together to eat. From the time Rajiv and Sanjay were boys, they would drop whatever they were doing and go home to lunch or dinner with the family. If Rajiv and I were spending the evening with friends, we would leave the house only after keeping his mother company while she ate.

This was by no means a burdensome duty. There would be lively conversation at the table: views exchanged, jokes traded. My mother-in-law was a delightful conversationalist — quick in her observation, clear in her descriptions. With the children particularly she would enjoy playing quiz games and telling stories. Her recollections of personalities and events of the Independence struggle would make history come alive and inspire in us a sense of belonging and participation.

She was the central person in the family. This position came to her, not from an exercise of authority, but from her capacity to love and to give. To us she was above all someone who shared generously — her wide range of interests, her warmth and her concern. When she was abroad, she wrote to us accounts of her meetings and experiences. When we were together, she would send us written messages — a reminder about a domestic chore, an observation quickly dashed off in the middle of a busy day. I received her first note from her office the day my mother left for Italy after my marriage: "Hi Sonia, just to say hello and to tell you that we all love you." One note to Rajiv refers to his photography: "You missed a beautiful picture. This morning in Akbar Road, two parakeets posed for quite a long time on the side of a tree trunk. There were also a couple of lovely woodpeckers but flitting about restlessly." If ever any differences arose between her and me, she would resolve them by the same method: "Tomorrow is Navroz. But I am leaving on tour early morning. May I come and kiss you *now*?"

She was spontaneous and informal, completely free of false pride. She was conscious of the contribution the family had been privileged to make to the country's history, and she passed this awareness on to her own sons as a responsibility for them to honour in their conduct. Her letters to Rajiv while he was in school often reiterate this belief. In a comment on a lapse by another family member, she wrote to him in 1958: "...One has to be extra careful about one's manners and behaviour, otherwise one brings discredit not only to the family but to the country as well."

MY mother-in-law's marriage had been full of ups and downs. Yet, as she once confided to me, she could not have married anyone but Feroze. He was the only man she ever loved. She spoke often and fondly of him. After her death I found among her papers a letter: "I am writing to you Sonia, because you seem to be interested in the family and also because I see some glimpses of myself in you and many of my husband in my son who is your husband."

She would frequently remark on how much Rajiv reminded her of Feroze — in temperament as well as in appearance. Like his father, Rajiv was mild and easy-going, slow to anger and, when seized by a fit of temper, quick to repent. Both were sensitive to beauty in nature, and to music. Both were down-to-earth, practical and deft with their hands.

Indira's letters to her father in prison often speak of her husband's enthusiasm for gardening. Jawaharlal's response is graphic: "I think of Anand Bhawan in the delightful cold of December, with the warm sun flooding the house and the garden with its cheerful presence; and you and Feroze busy in the garden and inside the house, improving them and changing their aspect; making them full of joyful life...." Many of the trees that have grown on the farm Feroze bought in the late '50s on the outskirts of Delhi were planted by him. Rajiv shared his father's pleasure in beautiful gardens, and planted his own favourite trees and shrubs wherever we lived. In his indoor spaces he liked symmetry, neatness and straight, functional lines. But when it came to landscaping, he preferred natural contours rather than formal settings with neat flower beds and trimmed bushes.

Among Rajiv's treasured keepsakes were his father's old projector and films of the family. He would periodically use and carefully maintain his father's workshop. He enjoyed tinkering with engines and machines, cleaning and fixing them. I would sometimes find myself hunting for an object of domestic use and discover it in his 'workshop'.

From the early days of our marriage, music and photography were important components of our lives. We went often to classical recitals of Indian as well as Western music. Because of his keen interest in quality sound and Indian classical music, Rajiv was able to personally record some of our great maestros. He would listen to jazz, which he loved particularly, and sometimes to rock and pop music. Over the years he built up a good collection of his favourite music, of which he took great care. He did not like anybody to touch his music equipment or records unless he was sure their handling was as careful as his own.

Rajiv was also very possessive about his pictures and slides, and would catalogue and store them with his customary neatness. He encouraged the children to take up photography as well: for instance, to develop their visual sensitivity by identifying different shades of green from the garden. Later, as their interest in photography grew, he advised them on technique. "I hope you are taking some pictures," he wrote to Rahul in school. "You must try and keep a note of the type of light and the exposure that you are giving so that when the pictures come then you will know what went wrong. If you keep a small booklet with you or a small diary then you can note something like this: 'picture 1 — sunny, speed 250, f 16' or whatever you had actually done. This way you will learn to correct your mistakes."

Operating an amateur radio station was another of Rajiv's absorbing interests. I would sit by his side late at night while he made contact with radio hams in India and abroad. He had painstakingly assembled his first radio set from a do-it-yourself kit in 1974 and he persuaded me and later the children to become amateur radio operators as well.

Rajiv had grown up with a variety of pets during his days with his grandfather, including some exotic animals (pandas, tiger cubs). Most of all he loved his dogs. They were generally Golden Retrievers, but one of his favourites, Sona, was a mongrel he had picked up in Pahalgam when he was a boy. A great many of the photographs he took in his boyhood are of his dogs. In 1969 we were given a puppy which we called Reshma. She was to become Rajiv's most loved pet, and when she died in 1982 he was greatly affected. He wrote to Rahul in school: "By the time you open this, Mama will already have told you that today at about 12:25 in the

afternoon Reshma died. She had been ill with cancer for a long time.... We are all very upset but this is the time that one has to think of the good times that you had with her. Think of how you played with her, how much fun she had and we had when we took her out.... I remember the first time that she got ill.... We sat up all night and all day for many days feeding her with a dropper.... Then as she grew bigger she became the boss even though she was the smallest!.... But you will learn to live with the fact that at some time we all have to die. It is very sad for the people that are still alive.... It is at times like these that on thinking back one remembers how one had behaved towards them, and if you can honestly say that you have no regrets then you can be proud of yourself, but if you can think of things that you feel were not nice or were positively nasty then you should try and correct yourself so that you don't have any such regrets in the future."

In Safdarjung Road, Rajiv used to keep watch over a bulbul's nest outside our window. If he ever came across a stray fledgling he would nurse it and if it was hurt he would send it to the Bird Hospital in Chandni Chowk. When a cobra was found in a tree-hole in Race Course Road, he would not let it be harmed. He kept a clay pot filled with millet in the garden for the birds. When we moved to Janpath, Rajiv would not allow us to disturb the nests which the sparrows had made inside our rooms. He would get up very early in the morning just to open our bedroom window so that the birds could fly out to gather food for their young. He would not allow the fan to be switched on, even if it was very hot, till they had flown away, for fear that they might get hurt.

Rajiv was the kind of person who would never pass by a road accident without stopping to ask if any help was needed; if necessary he would take the victim to the hospital and do his best to ensure follow-up care as well. His transparent kindness, his natural warmth, his humour and lack of affectation attracted most people. In his relationships with the extended family and his wide circle of friends, he was affectionate and concerned. The compassion and geniality that radiated from him came from a contentment deep within. It was a calm self-sufficiency, hard to describe. Yet he did not feel the need for intimacy in his friendships. There was no one outside his family to whom he ever turned to share his profound feelings of joy, sorrow or anxiety.

Within the extended family he was closer to those who had warm relationships with his mother. Like her, he was attentive to all the members of the family, whether Gandhis, Kauls or Nehrus, but not as particular about participation in clan gatherings. In this respect he was probably like most men of his generation who had spent their formative years away from home and more in the company of peers.

Rajiv's friends were either people who had shared his life in school and college, or his work and his many interests. In one of his letters to Rahul written in 1982, he explains very simply, almost prophetically, his view of friendship: "You will discover that it is not easy to make good friends... but if you are really lucky you will get one or two really good and dependable friends who will stick with you when things get bad. This should not upset you. As you grow up you will discover that a lot of people that you thought were your friends turn out not to be real friends.... If you want good friends then you must also learn to be one, you must learn to give and be happy with that."

This is a rare statement from Rajiv of a deeply held belief: that if you give in order to get something back, then that giving is worthless; only if you give selflessly can you experience contentment. Consequently, he was not one to harbour resentment if a friend let him down.

He would feel disappointed and hurt, but he would take the onus upon himself. Rather than blame the person concerned, he would question his own judgement. This was very much part of Rajiv's character throughout, even later when misunderstandings had more serious repercussions. Perhaps because he carried that equanimity within, he was also able to withstand the attacks upon himself.

Among his airline colleagues, Rajiv was respected as a conscientious professional, though they sometimes teased him for his meticulous attention to details of flight planning, schedules and technical aircraft problems. There he would not tolerate sloppiness, but he was always ready to oblige his fellow pilots if one of them asked him to take charge of a flight that for some reason they found inconvenient. And he was the least conscious of hierarchy. He had learnt from his father the dignity of labour — as he was to say later, "not hesitating to work with your hands, getting your hands oily and greasy". He would cheerfully roll up his sleeves and help the engineers fix a mechanical defect, but his workman's respect for craftsmanship made him impatient with negligence.

RAJIV and I were in Italy visiting my parents along with the children when the disaster occurred that was to alter all our lives — Sanjay's death, at the age of thirty-three, in a plane crash. It was a shattering blow for every member of the family, most of all for Rajiv's mother. My mother-in-law for all her courage and composure was broken in spirit. There was only one person in her world to whom she could turn for help.

For the first time in the fifteen years that we had known each other, there was tension between Rajiv and me. I fought like a tigress — for him, for us and our children, for the life we had made together, his flying which he loved, our uncomplicated, easy friendships, and, above all, for our freedom: that simple human right that we had so carefully and consistently preserved.

We had both observed the world of politics from a distance. We had come to understand the critical line that distinguishes ambition from a sense of purpose. To a few, power was important as an instrument to achieve a clear goal — to safeguard their political and cultural heritage, to help their society to go forward. To many, it was a necessary weapon to obtain personal or group dominance. In the first case, the reward was a sense of fulfillment; in the second, the trappings of power — the superficial glitter and glamour, the flattery and deference.

Rajiv was aware of the burden of power — the helplessness of an individual, in the face of misunderstanding created so easily by deliberate distortion: what strength was needed to remain silent! He had seen his mother struggling against impossible odds, day after day, year after year, committed to building a better future for her country. He had seen her stand fast against the thoughtless sneers of those who believed that to her power was an end in itself.

In the last few years Rajiv and I had seen politics from closer quarters. We had also been exposed to some of its worst aspects. Some of my mother-in-law's senior colleagues who had worked jointly with her in formulating policies and had supported her programmes had denounced her; political associates in whom she had placed her trust had turned their backs on her, becoming bitter critics; ordinary people had been intimidated by the vindictive campaign against her. We both knew exactly what life for Rajiv as a politician would be.

Rajiv was just as tormented by the conflict. There stood his mother, crushed and alone. How could he now at this time in her life when she needed him most turn away and choose the easy way out? I had come to love his mother as my own and I felt for her deeply. I

understood Rajiv's duty to her. At the same time I was angry and resentful towards a system which, as I saw it, demanded him as a sacrificial lamb. It would crush him and destroy him — of that I was absolutely certain.

I remember that long year as being one of complete helplessness, with every minute drawing us closer to the abyss. I kept hoping for a miracle, a solution which would be acceptable and fair to all of us. Finally, I realized that I could no longer bear to watch Rajiv being torn apart. He was my Rajiv, we loved each other, and if he felt that he ought to offer his help to his mother, then I would bow to those forces which were now beyond me to fight, and I would go with him wherever they took him.

FROM the moment Rajiv decided to go into politics, our lives were transformed. Earlier, his work had a different pattern: there were days of concentrated activity and long spans of leisure. Now it became the reverse. Before, it was an intimate, recognizable world. Now his life was crowded with people, hundreds of them every day, politicians, party workers, Amethi constituents, pressing him with their urgent problems and demands. His time was no longer flexible and each hour he could spend with us became all the more precious. We had to get accustomed to his frequent absences, when he was travelling or working late.

Rajiv was totally unruffled by the sudden claims on his time. At no point did I ever hear him complain about the stress he was exposed to or the loss of his privacy. It was as if he had accepted somewhere deep down the work he had to do and quietly made up his mind to get on with it. One of his letters to Rahul around this time reflects how much he was bringing of himself to his new life: "...When you have to do something you must remember that it must be done in the best way possible. There should not be a half-way point where you say it is good enough. You must always do your very best and then try a little harder. If it is just a race that you are running... you must put in that extra bit, that might make you feel that you are about to burst, only then can you get ahead.... You must try and work till you get perfection. It is all the little details that make the difference."

The more Rajiv became involved in his work, the more he felt the need for his family. Being now exposed to the ways of politics made him even more dependent on the stable, straightforward relationships he had in his own familiar world. There he didn't have to watch what he said, how much he said and to whom; we were there for him, a peaceful sanctuary from the political arena, with no strings attached to our love. He wrote to me around this time: "Like Hindu tradition says, a man is only half a person and his wife makes up the other half. I feel exactly like that. I know that without you I would find it very difficult... even more so now that I am in politics."

Even though I had accepted Rajiv's decision, it took me some time to come to terms with it within myself, particularly with the changes it was bringing to our life. Along with running the household as before, I joined a training course in restoration of oil paintings, an old interest of mine which I could not pursue earlier; I was careful to adjust my timings and engagements as far as possible to coincide with Rajiv's and my mother-in-law's free moments. Knowing how deep her wounds were, Rajiv and I felt even more protective towards her.

This was a time of other changes as well within the family. Rajiv wrote to Rahul in 1982, "I am going to Amethi... and Mama is also going.... It will be difficult for her as everyone will be staring at her in the beginning and she will feel very embarrassed till she gets a bit used to it. She is being very brave." Rahul had been sent to boarding school in 1982 and Priyanka was to go in

1983. Rajiv was firm in his view that the experience would help them grow up to be strong and independent, but he was concerned about their ability to cope with the intensified personal onslaught on the family. The children had faced similar problems earlier at school in Delhi when schoolmates sometimes taunted them, but we had been close by to support them.

He wrote frequently to Rahul, to reassure him: "Sometimes you will read all sorts of things in the papers about Dadi, Mama or about me but you should not worry. You might even find that some boys in school tease you about it but you will know that most of these things are not true.... You must learn to be able to face such provocations... to rise above all these irritants, and not let them bother you."

Meanwhile, the situation in Punjab had escalated into a serious danger to the country's unity. Secessionist forces were gathering strength, and brutal terrorist killings were mounting in number. We were warned that Rahul and Priyanka were terrorist targets, and as the danger increased the problem of managing their security in a boarding school became more acute. In the spring of 1984, they were admitted to schools in Delhi.

This was the first of many disruptions in their lives. However, it had its compensations. They were able to spend time with their grandmother in the last six months of her life. She was particularly happy to have them home with her again, though anxious about their safety. On more than one occasion she gave them strict instructions not to play beyond the gate which connected our home to her Akbar Road office. That was the spot where she was assassinated. Rajiv was to write to the children a few months later: "I am convinced that Dadi knew that she was going to die on that day — I don't know how or why she knew, but she did. Many things that she did indicate that she had prepared to leave us, not because she really wanted to, but because life had given her very hard decisions to make and she had chosen to do what was required of her, as a leader of her people."

AFTER Operation Blue Star, a shadow had entered our lives. My mother-in-law spoke to Rajiv and me about arrangements for her funeral. She wrote down her instructions. She talked to Rahul separately. She told him to be brave when the time came: she had lived her life and done all she had to do and could do; he was not to cry for her.

Life carried on. Diwali came round. Rajiv came back from Orissa to spend it with us, something he rarely failed to do. As always, my mother-in-law lit the oil lamp before the old image of Ganesh. We all joined in the ritual of illuminating the house and setting off the fire-crackers. Next morning, Rajiv left for West Bengal. That night, I woke up around 4:00 a.m., needing my asthma medication. I switched on the bedside lamp and crept towards the medicine cabinet, being careful not to disturb my mother-in-law in the next room. I was surprised when the door opened. With her torch on, she helped me find my tablet and gave me a glass of water. She told me to be sure to call out for her if I felt ill again. She had obviously been wide awake.

The next day she began to talk of going to Kashmir over the weekend. She wanted to see the chinar trees in their autumn colours. That seemed to hold a special significance for her. Was it an urge to bid farewell to her roots, to the memories and meanings Kashmir held for her? She was hesitant to stay overnight because she was worried about my being unwell and alone. In the end she decided to go with the children.

She returned on 28 October and spent a quiet evening in our room. As usual, she carried in her *mura* (cane stool) and her files from her study, and busied herself with her work, glancing occasionally at the television set or chatting to us. The next morning she left early for her

8

tour of Orissa and was back late the following evening. That day at a public meeting in Bhubaneshwar she had said: "It does not matter to me whether I live or die. As long as I draw breath I will carry on serving. And when I die, every drop of my blood will nourish and strengthen my free and undivided country."

31 October was going to be a full day, ending with an official dinner at home. In the morning, when Priyanka kissed her good-bye as usual before setting off to school, she hugged her very tightly. She called Rahul back and reminded him of what she had told him earlier. I went into her dressing room as she was getting ready. We spoke briefly about the menu for the evening, and as she was getting late for her appointment we decided that we would finalize the arrangements at lunch-time.

I had started my bath when I heard what sounded like an unusually close burst of Diwali firecrackers — but with a peculiar difference. I called out to the children's nanny to see what it was. I heard her screams. I knew at once something terrible had happened. I rushed out.... My mother-in-law had been placed in the back seat of an Ambassador car — stretched out lifeless. I knelt by her. It was a nightmarish drive to the hospital, slowly, through heavy traffic. Frantic, scattered thoughts: Was she just unconscious? Could she be saved somehow? Where was Rajiv? Where were the children? That strong refusal to believe that the worst had happened, that it was all over for her.

Hours passed. People, relatives, came and went. Someone said that the children had been fetched from school and brought to Safdarjung Road. Rajiv had been in West Bengal. He had been told that his mother had been injured. In the plane on his way back to Delhi he heard the news on the radio. He reached the hospital at 3:15 p.m. He was with other people, and I remember a longing to be left alone with him for a moment at least. As he spoke to me it sank in that they had asked him to become the party leader. He was going to be sworn in as Prime Minister. I begged him not to let them do this. I pleaded with him, with others around him, too. He would be killed as well. He held my hands, hugged me, tried to soothe my desperation. He had no choice, he said; he would be killed anyway.

On 19 November, my mother-in-law's birth anniversary, Rajiv and I drafted together identical and separately signed instructions for our children. Rajiv's said: "In the event of my death as well as that of my wife, Sonia, at or about the same time, at the same place or at different places, within or outside India, our bodies should be brought to Delhi and cremated together, in accordance with Hindu rites, in an open ground. In no circumstances should our bodies be burnt in a crematorium. According to our custom, our eldest child Rahul should light the pyre.... It is my wish that our ashes should be immersed into the Ganga at Triveni, Allahabad, where my ancestors' ashes have been immersed."

MY mother-in-law had been the centre of our universe. From the day I entered our home as a young bride, through our happy days and difficult times, she had been there, the pivot of our lives. Whatever happened — a problem to be solved, a squabble to be mediated, a special event to be celebrated — we would, each one of us, turn to her. She was there to guide us, admonish us, encourage us, love us.

For Rajiv, his mother was all that remained of his family. In the last four years she had become even more to him than the loving parent and friend he had always known. She had been his teacher, his leader. And for all that she had been to him, he could not mourn for her; there was no time to think of his own hurt or find expression for his grief.

One moment in the aftermath of the trauma stands out in my memory. I was searching for Rajiv in the house. Nobody seemed to know where he was. I found him in his mother's study, looking around at all the things that had been associated with her living presence. He felt utterly lost and alone. There were many occasions when he felt her absence intensely. At every turn in his public life, there were reminders of her which he had to face stoically. He had to draw upon all his inner courage and fortitude. On his young shoulders now lay the responsibility of a whole nation.

As soon as Rajiv was sworn in, the security forces closed in around our family. The system had given a shocking demonstration of its inadequacy: a Prime Minister gunned down in her own home, and not even the most basic emergency facilities at hand. Their presence put an end to what remained of our privacy and our freedom. The day of my mother-in-law's assassination was the last day Rahul and Priyanka ever attended school. In March 1985, we left 1 Safdarjung Road, where we had spent 15 years of our life together, for the house on Race Course Road designated by the Home Ministry as the Prime Minister's official residence. For the next five years the children remained at home, studying with tutors, virtually imprisoned. The only space outside our four walls where we could step without a cordon of security was our garden.

Rajiv was soon fully involved in his work. It took us a long time to recover from the shock of my mother-in-law's violent death. It is natural to fear for those one loves most. The children and I, being fully aware of the magnitude of the threat against Rajiv, did so constantly. When he was out, a slight delay in his schedule would automatically make us fear the worst. Slowly, we found our equilibrium. The children had their lessons in the morning and found ways to keep themselves occupied and distracted. I resumed my work at the National Museum and, during the long hours of waiting for Rajiv to come home from work, I edited a large collection of letters exchanged between my mother-in-law and her father from 1922 to 1964.

THE overwhelming response of the electorate in the 1984 General Elections made Rajiv aware of how much was expected of him. For three years he had been a Member of Parliament responsible for his own constituency, and one of the General Secretaries of the Congress Party. Now he had in his charge the 544 constituencies in the country and the management of a multi-party democracy. Being a newcomer to politics was his greatest asset: his approach to issues and people was fresh and open, and he questioned the old entrenched systems. He was young and full of energy. He had a vision and a goal for his country. Every step towards that goal brought him joy and satisfaction. Every obstacle was a further challenge.

He adopted a rigorous schedule which allowed him just four or five hours of sleep. All of us modified our habits to fit in with his routine. We would generally wait up for him — till 3:00 and more often 4:00 a.m. Next day he would be at his official work by 9:00 a.m., cheerful and alert. We would have our meals together most days. A 15-minute or at most half-hour nap afterwards was enough to refresh him. He had worked at that pace for stretches between 1981 and 1984; but it was now to become a regular, steady pattern. He seemed tireless. He would walk so fast that sometimes I had to ask him to slow down, seeing that the others with us were struggling to stay in step. On tours, he would cat-nap between scheduled stops, giving me strict instructions to wake him up if I saw anybody waiting for him. Sometimes I would let him catch a few more minutes of sleep and, if he found out, he would scold me. In Delhi the day would start with hundreds of visitors on the lawns outside Rajiv's Race Course Road

office. In addition to all the political and administrative work, there were ceremonial duties in which I also participated — welcoming and seeing off visiting dignitaries and attending official functions.

Wherever we went, Rajiv would find something interesting or curious to share. In a factory it would be machines, in a laboratory the experiments, in a village the people, the crops in their fields, the style of their buildings. He treasured every little object offered to him — an old Mizo lady's pipe, a bamboo basket, a carved shell. He sportingly put on the headgear and costumes people made him wear in different parts of the country as a symbol of welcome and brotherhood. Rajiv had a great capacity for fun and laughed at himself as readily as he did at absurdity in situations or people. He never took offence when he was teased, and so was perplexed when others misunderstood his sense of humour.

During my travels with Rajiv to the remotest and poorest parts of India, I experienced the depth of feeling people had for him, how much he cared for them and the extent to which their love energized him. Wherever Rajiv came in contact with people, at the most glittering function or in the poorest home, I could sense that immediate charge of excitement. It was more a response to his personal radiance than to the office he bore. It made little difference if it was a tribal village in the north, a town in Tamil Nadu, the heart of rural Punjab or the slums of Bombay. Rajiv did not belong to any group or caste or community. He was Indian and everyone saw him as their own.

Rajiv drove through most villages and towns in his jeep. Wherever people were waiting, we would stop. If we were delayed they would stand by patiently, to see him, to talk to him. Late at night in a far-off area an old lantern would be lifted close to Rajiv's face and then — that wonderful familiar glint of delight in their eyes at seeing his smile. They wanted him to meet their families, to name their newly born, to bless their young couples. He shared their meagre meals, he comforted them, he asked them questions, he listened attentively to their simple and frank description of their hardship. It was this direct contact with the people, and looking at problems from their viewpoint, that reinforced Rajiv's determination to bring in the changes and innovations he knew were needed.

Everywhere he went, within the country or abroad, strong-boxes of files and his personal computer travelled with him. On State visits he was also accompanied by a delegation of cabinet colleagues and members of his secretariat. During the journey, while I mostly sat alone, reading a book, Rajiv would be with his aides, revising speeches and putting finishing touches to the preparations. He slept very little on those long flights, and as soon as we touched ground we would be "on duty". For Rajiv this meant rounds of talks, conferences, signing agreements, visiting sites of the latest technological advances and attending ceremonial functions. After the day's formal programme was over, there would be further meetings with the members of his team to review issues which had cropped up. They all worked strenuously, enthused by Rajiv's drive. And what greater satisfaction for a man who loves his country than when through his effort she is honoured and heard! That was his reward.

Rajiv felt strongly that India's ethos of non-violence and tolerance would benefit the world in its quest for peace and justice. He carried his country's message to international meetings where critical issues were debated: the global environment, disarmament, a just economic order, the removal of racial barriers. There, too, his spontaneous warmth and friendliness broke the formality of the setting. His meeting with Mikhail Sergeyevich Gorbachev marked Rajiv's first visit overseas as Prime Minister. For General Secretary Gorbachev, too, it was the first

official reception of a foreign head of government. That faint trepidation Rajiv had felt just before stepping out of the plane in Moscow vanished as soon as they greeted each other. By the time we left, a warm working relationship had been established. It was the same with President Reagan and other world leaders. One of the most touching responses to Rajiv came when we visited the Frontline states of South Africa. There he was welcomed as a brother, with moist eyes and warm embraces. They honoured him, as they had his mother and grandfather, for India's passionate support of their cause. They knew that in Rajiv they had a dedicated ally.

Beneath the cheerful composure and lightness of spirit with which Rajiv shouldered his work was a rock-like fortitude and single-mindedness. It saw him through the relentless personal attack his political opponents mounted against him. He had an internal mechanism which steadied him unfailingly through the turmoil around. A letter he wrote to me in 1983 describes it very simply: "...Those things that I find truly important I do remember, but other things are just thrown out of my mind almost immediately. Just like I don't feel like seeing a lot of clutter in a room, I don't like to have it in my mind and what I feel that I don't need, I throw out." That is how, throughout the period of his Prime Ministership, he never lost his confidence and drive. He remained serene, concentrating on what was to him significant and worthwhile. It was in the conviction that his work and sincerity of purpose would speak for themselves that he did not feel the need to constantly explain or defend himself.

However, Rajiv was not simply a man carrying the responsibility for a nation of 850 million; he was also a member of a family which had held office almost without interruption since 1947. For both these reasons he was loved and respected by most. For the same reasons, he was resented by many. He could not bring about the changes needed without disturbing the system, and he could not be Prime Minister without inviting the same animosity which had been directed at his mother and grandfather.

There had traditionally been only one point on which all the elements of opposition to the government found a focus in coming together. In 1989, once again, the right and left wing parties joined forces with those of the old Janata Party and some in the Congress who viewed Rajiv as a block to their political or personal objectives. Together they formed an electoral platform with one aim: the removal of Rajiv.

For all the complexities of a developing country undergoing rapid change, Rajiv's government had performed well. It had brought in new policies, fresh initiatives. It had managed economic crises efficiently. Many of the conflicts it inherited in 1984 had been resolved. Inevitably, new ones had arisen in their place, but within, India remained united; in the world, India stood tall. Rajiv's 1989 election campaign focused on his government's achievements, the country's priorities, and his party's programme for the future. The Opposition campaign was an onslaught of slander and abuse of Rajiv and our family. There is no more apt analysis of the events of that period than Rajiv's own observation in a letter to Priyanka: "The real world is quite a jungle, but even the laws of the jungle don't hold when you are in public life."

As the election results came in, it became clear that the Congress Party could not form a government on its own. Even though his party had the largest number of seats, Rajiv unhesitatingly resigned. His immediate reaction was deep disappointment: there was so much he had set out to do, so much still to be accomplished. He had experienced how difficult it was to build, and understood how easily it could all be destroyed. He had committed himself to his mission, and his faith would not be broken. He would not be beaten; he would fight on.

12

THE new government took office. The Congress was still the largest party in the Lok Sabha and Rajiv became the Leader of the Opposition. We moved out of the Prime Minister's residence and into our new home, 10 Janpath. Rajiv was fully occupied with his work in Parliament and as Party president, but the pace was easier, the mental and physical load lighter. He was relaxed, almost relieved, as if a heavy cross had been lifted from his shoulder. He savoured simple, everyday pleasures again — uninterrupted meals, sitting with all of us in tranquillity, occasionally watching a video film instead of working at his desk on official papers. He had said in an interview, "I miss not being able to be a real human being. I can't take the family out. You can't go for a picnic or a meal... It is something that just got lost." We drove to Mussoorie for a three-day stay in August just before his last birthday — our first break in 19 months. Our farmhouse in Mehrauli had been completed in 1985, but we had rarely spent more than a few hours there on a Sunday. In 1990 we lived there for almost a week over the New Year. It was the only time we ever stayed in a house that was entirely ours. Rajiv had supervised every detail of its construction over ten years. We loved every minute of those six days. They brought back memories of our life as it had been in the beginning, and a flavour of the one we would have had if we had been able to choose for ourselves.

By the time we moved out of Race Course Road, Rahul and Priyanka were young adults. Rajiv and I had so often experienced that helpless feeling of being caught between their need to live in the freedom we had known and our responsibility for their safety. This feeling was reflected in a letter Rajiv had written to them: "Both of you have been living under very difficult conditions for some years now. This is the period in your life when you should have been getting about, meeting others your age, finding out about the world as it really is. Unfortunately, circumstances have been such that we have not been able to give you both a normal life. Your schooling was disturbed and ultimately you have had to study at home. Your movements are severely restricted and you can't even go out." Once they finished school, however, they could no longer be tutored at home. They started going to college in the summer of 1989, and by the middle of the next year Rahul was at a university in the USA. While Rajiv took great delight in sharing the excitement of their new experiences, the reports he received on their safety were a source of continuing disquiet.

The danger to Rajiv's life had intensified. In 1984 the threat had been from three extremist groups. There had been two attempts on his life, on 2 October 1986 in Delhi and on 30 July 1987 in Colombo. By 1989 there were a dozen major terrorist outfits: for each of them he was the number one target. Effective security could only have been provided by a force of specially trained men, such as was available in the "Special Protection Group" guarding Rajiv. The new government was well aware of this. Yet it withdrew Rajiv's specialized security cover and replaced it with a force not trained for this specific task.

Every day brought new and glaring examples of how lightly Rajiv's security was viewed and how carelessly it was handled. Every time Priyanka and I saw him off on a tour accompanied by just one Personal Security Officer (this became two on a rota, just a month before the election campaign), we would be uneasy till he returned. Rahul would telephone from America, consumed with anxiety. He insisted on coming home at the end of March 1991 for his Easter break. He accompanied Rajiv on a tour to Bihar and was appalled to witness the lack of elementary security around his father. Before going back he told me that if something was not done about it, he knew he would soon come home for his father's funeral.

We spent 25 February 1991, our wedding anniversary, in Teheran. Rajiv had insisted that I accompany him on this trip: I was in his constituency, but he made me cancel my engagements in Amethi at short notice. He had earlier written: "I feel like... [being] with you, only you and I, the two of us alone, without two hundred people always about us." He did not want us to be apart on the day which for us had always been so special. As I arrived home in the middle of the night, he told me how anxious he had been that I might not be able to reach Delhi in time. I found that he had already had my things taken out and packed. In Teheran, at midnight on 24 February, he gave me the gift which he had carried from Delhi. The next evening, after his official engagements, we dined out at a restaurant, which we had not been able to do for many years. When we returned to the hotel, Rajiv took out his camera, which he generally carried, and on a light-hearted impulse we posed for a self-timed picture of us together, something we had never done before...

Rajiv's fears for the country were soon to be borne out by events. While the Congress Party in its moment of crisis stood united under Rajiv's leadership, the National Front alliance in its moment of electoral victory began its process of disintegration. Its personal and political squabbles took the country into chaos of a kind never before witnessed. To see the careful work of nation-building being so wantonly and rapidly destroyed made Rajiv and all those who cared for the country sad and angry. Within sixteen months there had been two changes of government, and in April 1991 fresh elections were announced.

ON 28 April, Rajiv and Priyanka saw me off to Amethi from Safdarjung airport. I was to camp there for the next three weeks while he was travelling to all parts of India. In earlier elections he had visited his constituency. This time he left the canvassing to me. Our only contact during the period was to be on the telephone in the first week; later I got news of him from Priyanka and, when she too joined me in Amethi, from members of our staff whenever I called home. Just before setting off on his campaign, Rajiv sent me from Delhi a gift of a rose with his written message of love. This was going to be the longest stretch of time away from each other in twenty-three years.

Priyanka and I returned home on 17 May. Rajiv joined us the following evening, 18 May. He was exhausted. He could barely walk or speak. He had not slept or eaten properly for weeks. He had been campaigning an average of 20 to 22 hours a day. His hands and arms were badly scratched and swollen. His body was bruised and aching. Hundreds and thousands of well-wishers wanted to touch him, to shake his hands, to give him a brotherly hug, or an affectionate thump on his back. It broke my heart to see him in that state. "Yes, it hurts," he said, "but it doesn't matter." They were after all his brothers, his sisters, his children. Stretched out with a bolster under his feet, he told me about his gruelling tours. He had encountered so much love, so much enthusiasm. However, it was going to be a tough fight. I chatted with him about my experiences in his constituency. He slept for a rare five hours that night, and early next morning, 19 May, he left for Bhopal. He returned late the same night, dead tired again but with a sense of relief: the campaign was drawing to a close and he would be home and able to have "at least one good night's sleep". Later he would have to busy himself in the intense political activity which would inevitably follow the election. Priyanka and I, too, were happy. The campaign in Amethi was over, and we were confident of a good victory for Rajiv. On 23 May, Rahul was also coming home for his summer break. Soon we were all going to be together again.

On the morning of 20 May, Rajiv and I drove to the polling booth at 7:30 a.m. to cast our votes. On the way back I told him how I had nearly panicked when I could not find the Congress Party symbol on that huge ballot paper. I thought for a moment I would have to walk away without casting my vote for him. He laughed. He held my hand with that gentle, reassuring touch which had always helped to dispel any feeling of anxiety or hurt. It was time for him to leave for his next tour. In the evening he was to touch Delhi again, but only to change from the helicopter to a plane that would take him to Orissa.

That afternoon we received a message at about 4:15 that he was on his way home. He walked in beaming. We were delighted at the unexpected chance to spend a few more minutes together. He had a quick wash and a snack. He spoke briefly on the phone to Rahul, to wish him well for his coming test and to give him his love. He said goodbye to Priyanka. Once again, it was time for him to go. I would now see him, as he himself announced cheerfully, in "just two more days". We bade each other a tender goodbye... and he was off. I watched him, peeping from behind the curtain, till he disappeared from view....

This time forever.

THE LIFE THAT RAJIV CHOSE

The family of Feroze Gandhi, Rajiv's father, were Gujarati Parsis. Jehangir Faridoon, a marine engineer in Bombay, and his wife Rattimai (far left) had five children, of whom Feroze, born on 12 September 1912, was the youngest. When Feroze was about a year old, he was brought with his sister Tehmina to Allahabad to live with his maternal aunt Shireen Commissariat (left), a surgeon by profession. Feroze was ten when his father died following a prolonged illness, and the rest of the family also moved to Allahabad, where they lived with Dr Commissariat.

Indira Priyadarshini Nehru's family were Kashmiri Pandits. Her father Jawaharlal Nehru was the son of a wealthy and influential lawyer of Allahabad, Motilal Nehru. Her mother Kamala came from a branch of the Kaul family in Delhi. Indira, their only child, was born on 19 November 1917. Jawaharlal was trained as a lawyer, too, but the nationalist struggle soon became his vocation. Under the influence of Mahatma Gandhi, the affluent Nehrus' life-style changed dramatically. The women of the household, too, actively participated in demonstrations and processions; young Feroze, by then a political activist, would often escort them to meetings and protect them from police *lathis* [truncheons]. Shy and sensitive as Kamala was, she responded with her affection and trust to Feroze's sincerity and he became a frequent visitor to the Nehru ancestral home, Anand Bhawan.

"I first met Feroze when I was thirteen and he eighteen – he had saved a fistful of sticky sweets for me!" wrote Indira to her friend Dorothy Norman. As Indira blossomed into a young woman, Feroze's feelings for her grew stronger. They agreed to marry when she was 19 years old, though it was another six years before they became man and wife.

"Although Feroze had been proposing to me since I was 16, it was on the steps of the [Basilica of] *Sacre-Coeur* that we finally and definitely decided. It was the end of Summer, Paris was bathed in soft sunshine and her heart truly seemed to be young and gay, not only because we ourselves were young and in love but because the whole city was swarming with people who were young at heart and in a holiday mood."

The portrait of Indira Nehru on this page is one of a set of four taken in London in a photographer's studio, following several requests from her father. Feroze Gandhi's is also from a set, possibly self-timed and taken, which he sent to her. One of them is inscribed: *"To my only possession dearer than life."*

The engagement of Feroze and Indira, one a Parsi and the other a Hindu, created a storm among orthodox Hindus. Both Jawaharlal Nehru and Mahatma Gandhi received angry letters urging them to prevent the marriage. Jawaharlal issued a statement in which he declared: "A marriage is a personal and domestic matter, affecting chiefly the two parties concerned and partly their families.... I have long held the view that though parents may and should advise in the matter, the choice and ultimate decision must lie with the two parties concerned.... When I was assured that Indira and Feroze wanted to marry one another I accepted willingly their decision and told them that it had my blessing.... But on whomsoever my daughter's choice would have fallen, I would have accepted it or been false to the principles I have held."

Gandhiji's statement bears out the wisdom and tolerance of the Mahatma: *"Feroze Gandhi has been for years an intimate of the Nehru family. He nursed Kamala Nehru in her sickness. He was like a son to her. During Indira's illness in Europe he was of great help to her.*

A natural intimacy grew up between them. The friendship has been perfectly honourable. It has ripened into mutual attraction. But neither party would think of marrying without the consent and blessing of Jawaharlal Nehru. This was given only after he was satisfied that the attraction had a solid base. The public know my connection with the Nehrus. I also had talks with both the parties. It would have been cruelty to refuse consent to this engagement.

"As time advances such unions are bound to multiply with benefit to society.... No religion which is narrow and which cannot satisfy the test of reason will survive the coming reconstruction of society in which values will have changed and character, not possession of wealth, title or birth, will be the sole test of merit.

"The Hinduism of my conception is no narrow creed. It is a grand evolutionary process, as ancient as time and embraces the teachings of Zoroaster, Moses and other prophets I could name."

The wedding took place on 26 March 1942 in Anand Bhawan. The sari Indira wore for the occasion was of light pink *khadi*, woven from cotton yarn spun by her father in prison.

The traditional Vedic ceremony was modified by Jawaharlal to include a Sanskrit verse in which Indira pledged: *"If there are any people in the four quarters of the earth, who venture to deprive us of our freedom, mark! Here I am, sword in hand, prepared to resist them to the last! I pray for the spreading light of freedom; may it envelop us on all sides!"*

Immediately after the wedding, Feroze and Indira became involved in a session of the All India Congress Committee in Allahabad, and it was two months before they could get away to Kashmir on their honeymoon. (The photographs on these pages are by Feroze and Indira, and some by family friends whom they met in Kashmir. Sheikh Abdullah is in the group.)

Soon after their return, on 9 August, the day all the members of the Congress Working Committee were arrested, Indira had her first experience of being tear-gassed. In September, both she and Feroze were arrested and imprisoned separately in Naini Jail near Allahabad.

21

Rajiv was born at 8 a.m. on 20 August 1944 at the Belle Vue Nursing Home in Bombay. His birth weight was recorded as 6.5 lbs and his height as 19.5 inches. Jawaharlal was in prison and Feroze sent him a telegram immediately. Mother and infant were looked after by Indira's paternal aunt Krishna Hutheesing and other relatives.

The earliest photographs of Rajiv were taken by his father. Sending them to Jawaharlal in prison, Indira wrote: "*The one with me was taken some days before the others – we were both in rather a bad mood. It was baby's feeding time and he was yelling away at the top of his tiny voice and Rajabhai* [Raja Hutheesing] *and Feroze were giving me lengthy advice on how to pose him.*" She described her baby with delight: "*The most wonderful thing about him, as indeed about any baby, is his rose-petal skin. Few flowers are so soft and smooth.*"

On 14 September, Gandhiji sent for Indira and Rajiv. She wrote to her father about the visit: "*Fortunately baby was asleep the whole time.*" (Mrs Hutheesing is seen but neither mother nor baby are visible in the photograph taken on the occasion.) "*Bapu was lying down but he held baby for a while and afterwards gave both of us his birthday* prasad [offering] *of almonds and raisins.*"

Rajiv's early stages of growth were recorded by Indira almost from day to day in his "Baby Book". Her correspondence with her father in prison and with her husband during his absences provides further details of his development.

On 16 October, Indira records the receipt of a letter addressed to Rajiv by the poet Sarojini Naidu: "*My dear little great nephew.... The blessing that I send you for your first Diwali on this earth will light a lamp for you that can never be put out by any wind of fate. It will shed a bright and happy lustre around your childhood's games. It will shine over your lessons when you are at school and it will illumine your path when you are a man doing a man's brave duty in the world. For, my little great-nephew, you inherit a famous ancestry and a high tradition. You are in fact yourself the lamp of life for your household.... In a free India which will be, you know, you will achieve a splendid manhood and be a leader among those who dedicate their talents, their time, their hope and faith and service to the redeeming of humanity from evil. The world will be your country and all mankind your kindred. So little one...celebrating so unconsciously your first Festival of Lights, you will be yourself a living and imperishable flame to light the world.*"

Indira sent this studio photograph, taken in Lahore in May 1945, to her husband in Lucknow and to her father in the Ahmednagar Fort prison. She wrote to her husband frequently, providing him with accounts of Rajiv's growth and unfolding personality:

"Rajiv looks more and more like you. Although I think he has something of me too. He is perfectly adorable! Nazar na lage [May he be spared the evil eye]."
(Srinagar, 24 May 1945)

"Rajiv seems to learn something new every day. I do wish you were here to take a film of him. He is so sweet at this stage it would be worthwhile to have a permanent record of his antics."
(Srinagar, 7 June 1945)

"Rajiv loves animals. He crawls after the hens at a terrible speed. But he simply adores horses and loves to sit on one as soon as he sees it." (Srinagar, 23 July 1945)

"Everybody who sees him is in love with him.... He is quite cute about opening bolts and things.... He will soon learn to push open a spring door."
(Gulmarg, 24 August 1945)

Indira was in Srinagar with Rajiv when she heard the news on the radio that the British Government was to initiate a constitutional dialogue with the leaders of India. It was one of the most exhilarating moments of her life, a moment for which so many had worked and sacrificed. She left Rajiv with relatives and rushed to Allahabad to her father's side.

In June 1945, Jawaharlal Nehru and other leaders were invited to the Simla Conference. Indira returned to Kashmir, where her father later joined her. On 20 August 1945, Rajiv's first birthday, his formal christening or *namkaran* was celebrated in Srinagar.

The naming of Rajiv was an elaborate affair, as is often the case with a first child. A large number of suggestions had come in from friends, relatives, political colleagues and well-wishers. In jail, Jawaharlal consulted Maulana Azad, Asaf Ali, Narendra Dev and others. An exhaustive list was drawn up, and the meaning of the names discussed at length. Eventually it was decided to name the child Rajiva Ratna, a combination of "lotus" for Kamala (Indira Gandhi's mother) and "gem" for the first three syllables of Jawaharlal. In his Baby Book, his full name is entered as Rajiva Ratna Birjees Nehru Gandhi.

Indira wrote a brief description of the ceremony to Feroze who was working in Lucknow and unable to attend: "[Rajiv] *was dressed in white* khadi-kurta, tang [close-fitting] *pyjamas,* Gandhi *topi. We had a short ceremony for the* namkaran *and* khir chatai [ritual tasting of rice pudding]. *Then there were refreshments. We had put this in charge of Pestonjee. So there were all the things Parsis have for birthdays."*

26

When the photograph on the facing page was taken on the occasion of Rajiv's name-giving ceremony, no one could have imagined that the camera lens was focussed on three future Prime Ministers of India.

The pictures on this page, taken in Anand Bhawan soon after, mark a watershed in the lives of this family: the prison years behind them, a free India ahead. Jawaharlal Nehru and other leaders were at this time engaged in negotiations with the British to set up the Interim Government in the following year. Nehru would become its de facto First Executive.

Rajiv stood unaided for the first time on 15 August 1945, his mother records in his Baby Book. Back in Anand Bhawan in September, he had two pets, a wire-haired terrier called 'Breezy' and a deer. By November he was walking and running, climbing up and down.

In March 1946 Indira wrote to her father: "*Rajiv is learning so fast it is almost impossible to keep pace. Bebee* [Padmaja Naidu] *suggested the other day that we should make a list of all the words he used – it comes to 150 and we are constantly discovering new ones. Two of the words he has recently acquired are Sitaram and Allah!*"

Through these long and intimate letters, Jawaharlal had shared in all the stages of Rajiv's infancy. But now, for the first time, Rajiv's grandfather became a living presence in his world. Indira wrote to Jawaharlal in August 1946, "*Rajiv has tried to telephone you twice. And once when the phone rang, he picked it up and would not give it to me, saying, 'Nana baba ko bulata hai' [Grandfather is calling Baby].*"

Rajiv and Indira in Delhi in August 1946, around the time of his second birthday. Over the next three years Indira was to divide her time between her father and her husband. Jawaharlal Nehru was living in Delhi at 17 York Road (now Motilal Nehru Marg) and depended greatly on his daughter to help him with the constant stream of guests and visitors. "*My husband was then working in Lucknow and I used to go there,*" she recalled later. "*But invariably I would get a telegram: 'Important guest coming, return at once.' My father would feel so hurt if I did not come that it was very difficult to say no. It was a real problem, because, naturally, Feroze did not always appreciate my going away. I was living about half the month in Lucknow and half in Delhi, until Feroze became a Member of the Constituent Assembly. Then, of course, he came to Delhi and we could all be together.*"

Photo Central, Bombay.

Rajiv started his lifetime of travel rather early. His Baby Book records in his mother's hand his itinerary between April and September 1946: "*I came to Delhi in April, then went to Allahabad, Lucknow, Nainital, Khali, back to Lucknow, then Bombay. I flew from Delhi to Allahabad and again from Cawnpore [Kanpur] to Bombay. I was sick both times.*"

However, the political currents of 1947 were steadily drawing his family to make their home in the capital.

The photographs on this page were taken in Delhi on 26 January 1947, and the bust of Rajiv was done the same year by Clara Quien.

Rajiv's brother Sanjay was born in Delhi on 14 December 1946. These photographs (of which no negatives have been found) were taken by Feroze a few months later at Jawaharlal's York Road home.

Because Indira's own childhood had been, as she said, "an abnormal one, full of loneliness and insecurity" on account of the political struggle, she was a conscientious mother. "*When Rajiv and Sanjay were babies I did not like the idea of anyone else attending to their needs,*" she said later. They had a Danish governess, Tante Anna, a great disciplinarian, but Indira was very much a part of their daily routines.

34

(Facing page) An image for 1947, the year of India's independence: the Viceroy, Earl Mountbatten, greets a young representative of the new nation. The picture was taken in September 1947 at Jawaharlal's York Road residence.

On 15 August 1948, the 4-year-old Rajiv was invited to hoist the tricolour at a public meeting organized at Kashmiri Gate, Delhi, by the All India Children's Association.

In 1948, Indira and her children moved with Jawaharlal to Teen Murti House, the Prime Minister's official residence, which was to be their home for the next 16 years.

Feroze spent a great deal of time with his sons, sharing with them his many interests. Rajiv's manual dexterity and fascination with machines, and later with photography and landscaping, were directly derived from his father.

Here, visiting Palam airport with Feroze to see Jawaharlal and Indira off on an overseas tour, Rajiv experiences the thrill of sitting in the cockpit of a fighter plane. (Also seen are Rita and Lekha, the daughters of Jawaharlal's elder sister, Vijayalaxmi Pandit.)

Jawaharlal was a formative influence in Rajiv's life. Living at Teen Murti House meant travel around the country and abroad, and meeting visitors from all over the world. (This exposure had its hazards: Rajiv disliked being in the public eye, and confessed later that he used to be greatly embarrassed by the attention Jawaharlal's family seemed to attract.)

Jawaharlal shared and encouraged some of his grandsons' interests. Later, Rajiv was to recall: "*My interest in flying really started when my grandfather took me to the gliding club...That was when I had my first ride in a glider, and that was when I got hooked.*" Most of all, it was from his grandfather that Rajiv absorbed the liberal, humanistic outlook which was to become the framework of his own value system.

In a letter dated 30 December 1950, written after a gap of many years to her old teacher in Switzerland, Indira describes her family and her life at this period: "I have two boys. Rajiv is now six and a half years and Sanjaya four years. They are as different as can be. Rajiv, the elder, is quiet and sensitive. His teacher writes 'There is a capacity for great emotional intensity and strong attachments, an almost too great, sensitive awareness of environment and people... He shows keen and enthusiastic interest in every possible topic. Understands and remembers information well, takes lively interest in group discussions and is able to supply a good bit of interesting and relevant information, gathered from other sources, himself...' The little one goes to school too but doesn't do anything except drawing and cutting paper shapes. He is very talkative and lively and full of fun. He is generally more popular than his brother, especially with strangers. The boys go to a small private school run by a German lady who has lived many years in India and is married to an Indian. [Elizabeth Gauba's School on Hailey Road — see photograph above of the annual school function.]

"I keep house for my father and act as hostess. We have to do an enormous amount of entertaining. Privately as well as officially. One meets a lot of interesting people from all over the world...

"My husband is a member of Parliament and whenever Parliament is in session he comes and stays in Delhi. The rest of the time he lives in Lucknow, which is one whole night's journey by train. He is the Managing Director of a newspaper. He loves the work but finds it arduous and exacting. I keep travelling between Delhi and Lucknow, it is tiring and exhausting.

"Apart from my social duties, I have to interview large numbers of refugees and other people in distress and I belong to numerous committees concerning hospitals, child welfare institutions and so on. As a form of relaxation I have now joined the 'Delhi Bird-Watching Society'! It is such a change from politics and diplomacy and all the serious aspects of life."

40

The portrait of Rajiv aged seven (left) was taken by Feroze in Pahalgam in Kashmir; it was a favourite of his mother.

In May 1953, Indira accompanied Jawaharlal to London to attend the coronation of Queen Elizabeth II. Rajiv and Sanjay spent part of the summer in Goldern (Switzerland) at the 'Ecole d'Humanite' run by the famous educationist Paulus Geheeb (below, left).

Indira's approach to the education of her sons was remarkably broad-minded. She had never been an academic performer herself, but relied on her eager, questing intelligence to absorb all she wanted to know. She valued breadth of outlook above grades and marks, and never hesitated to take the children away from their books to share some new experience of people and places.

Her abundant letters to Rajiv during his school years reflect this open-mindedness. They are full of jokes, puzzles, and reflections on a variety of her concerns, ranging from the politics of race relations to the splendour of the tiger. She was an environmentalist long before it became fashionable, and this too was part of the code she imparted to her children.

With the sheltered world of childhood behind him, Rajiv at ten years was sent to the Welham Boys' School in Dehra Dun as a boarder. It was not an easy adjustment for a shy and sensitive child. Both his parents, greatly concerned, kept constantly in touch, writing regularly and visiting him when school rules permitted.

In November 1954 his father wrote:

"My very dear Rajiv, It was so wonderful to have you with me for a few days. I hope you enjoyed your visit as much as I did. It was after a very long time that we got the chance of being with each other and talking to each other..... Now I miss you very much..... I am anxiously looking forward to your coming home in December. You and me can finish building the 'Konitiki' then..... You must try and write more.... It is not very difficult. Write about anything you please and don't be afraid of anything you write."

In 1955, while holidaying with Feroze in Dalhousie, Rajiv fractured his arm. Indira was abroad, and her letter to her boys is significant: "....One must not be afraid of being hurt. The world is full of all kinds of hurts and it is only by facing them that we can become strong and hardy and able to do great things. All good riders have had many falls from their horses, just as all first-class skiers have broken some bones at one time or another. It is a price one has to pay and it is well worth paying..... You know how much I want both of you to be courageous in mind and body. There are millions of people in the world but most of them just drift along, afraid of death and even more afraid of life."

42

Rajiv and Sanjay shared the normal comradeship of brothers. Sanjay called Rajiv 'Bhi', an affectionate contraction of 'Bhai' [Brother]. They had many interests in common: mechanical gadgets, flying, photography, fostered in their relationship with their father. 'Pi', as Feroze was called by his sons, had a workshop next to his room with a lathe where he taught his boys to make model ships and planes, toys and objects of use.

Rajiv recalled in later years: "*There were a lot of things where Sanjay and I had very similar views. In some areas we had differences. Sometimes we fought like mad, at other times we were very good friends. He was much more extrovert, I'm much more introverted.*"

Two photographs of Rajiv on the threshold of adolescence reflect his quiet, inward-looking personality; whatever the magnitude of his anxiety or pain, he would cope with it in solitude and silence. Even to the closest person in his life he never spoke of the distress he must have experienced when his parents went through a temporary estrangement in 1958. Feroze and Indira were to remain always emotionally bound to each other, whether living together or apart,

and the rift was to be healed towards the end of 1959; but at that stage the complexities of his parents' relationship could have been for a child hard to grasp. Years later, Rajiv wrote to me about his parents: ''I think that they both loved each other very much and had a lot of happiness and comfort out of the marriage. *They both hated hypocrisy and 'patchwork' treatment (leaving things half-done). But they were so different in nature that they also exasperated each other.''*

"*We all liked your 'lino-cuts' very much,*"
wrote Indira to Rajiv in April 1957. "*I
am thinking of having them framed in my
room. They came while the Russian artists
who were painting my portrait were still here
and they also were quite excited about them
and thought that you should become an
artist! I told them you were much more
interested in aeroplanes and machines.*"

Once he had settled down in boarding
school, Rajiv happily absorbed himself in
all the activities and opportunities
provided by the Doon School, happy to
be just another boy among his
schoolmates. He enjoyed mathematics,
geography, carpentry and drawing.
Always adept at working with his hands,
he developed a visual sensibility as well
that later came to find expression in his
photography.

In school and later, Rajiv was not a great devotee of team sports. However, he had a normal schoolboy's reverence for sports heroes, and his delight at shaking hands with India's champion wrestler Dara Singh is evident.

Rajiv liked trekking and swimming and was good at both. Group photographs from the Doon School show Rajiv (above, back row, extreme right) in 1957 in Kashmir House; (facing page, above) in 1958 in the swimming team, seated fifth from left; and (below) in 1960, fourth from left.

Rajiv qualified for the Intermediate Certificate of the Royal Life Saving Society and, in 1959, for the Scholar Instructor's Certificate. "*Darling Rajiv, your Life Saving Certificate has just come. I am practically bursting with pride and it is a lovely feeling,*" Indira wrote.

49

In 1960, just two months before Rajiv's school leaving exam, Feroze died suddenly of a heart attack. The loss of a parent in adolescence is always difficult, and Rajiv had loved his father deeply. Many years later, he spoke about it in an interview: "*The last time I remember seeing my father alive was on a holiday we had all gone [on], the whole family together, the four of us. We had spent about a month in Kashmir in a houseboat and after a very long time the family was united and together and some of the old problems had disappeared. It was a very happy period.... It was the first death of a close person and I went through a very difficult period, but we had been brought up to be perhaps a bit stoic, and I kept it all inside, I did not let it*

come out or show in any way."

This was a matter of some concern to Indira, who wrote to him in school: "*I don't know what to write – The first three days I was quite numb and although my eyes were aching and burning, I could not really cry – but now I have begun to cry and don't seem to be able to stop. I have never before known such utter desolation and grief. I look at things and people but don't really see them. Everything seems so dark. What am I going to do? This dreadful thing has happened just when I thought everything was going well and that we might all live together as a family again. However, you are young and brave and have many other qualities of which we are proud. Your life lies before you and I do not wish to burden*

you with my sorrow. However much one loves one's father, it is not as close a relationship as that of a husband and wife. There is one thing about which I want to warn you. You never talk – that is, about what is really in your mind. It was this same trait in Papa which caused him so much mental suffering, and prevented me from doing so many things to help him. If you do not talk, how can I do so? And that is what makes for loneliness."

It was some time later that Rajiv's repressed feelings came to the surface. Indira wrote to her father on 9 March 1961, when she had gone to the funeral of freedom fighter G.B. Pant." Rajiv had gone to Panditji's house in the morning all by himself. He came to the airport to fetch me

and accompanied us to the ghat. After a while I saw his face crumpling up and sent him home on the excuse that it was getting chilly. When I came home about two hours later, I found he had been crying and vomiting and had a severe headache. I do not know if I told you that throughout Panditji's illness he had been most concerned. Probably, this has reminded him of Feroze. He was thoroughly upset and just could not get to sleep. I sat up with him at night and decided that it would be a good thing for us both to get away from here. As I have anyhow to go to Bombay to fulfil the engagements which were postponed, I thought I would take advantage of this to have a bit of a change and to take Rajiv to Ajanta and Ellora which neither of us have seen."

52

Rajiv was in his seventeenth year when he finished school, Jawaharlal had been keen to send him to Harrow for his 'A' levels after Doon School, and then to Cambridge for a degree in mechanical engineering. Indira was not initially in favour of Rajiv going abroad at such a tender age, but was persuaded to let him study for his Cambridge entrance exam, which he passed in London in August 1962.

In between, he escorted his mother on a lecture tour of the USA. He visited the Boeing aircraft plant in Seattle and Beechcraft Facilities (above) in Kansas. Indira wrote proudly to her father: "*For me it was a great joy to have him along and he was a good ambassador for India amongst the younger set.*"

In October 1962, Indira took Rajiv up to Cambridge, to his grandfather's college, Trinity. She wrote to Dorothy: "*It is rather a poignant moment, isn't it, for a mother when her child becomes a man and she knows that he is no longer dependent on her and that from now on he will lead his own life which she may or may not be allowed to glimpse. And even if she does sometimes look in, it can only be from outside, across the gap of a generation. New friendships, new attachments, new loves. My heart aches, but such is life. Not for nothing did our ancients leave all family attachments at a certain age and retire to meditate on the strangeness of the world and the Almighty. I wish I could – not necessarily meditate but retire anyway! As for Rajiv, I can only hope and pray that he will have the strength to face and accept life in all its varied facets.*"

For the next four years, Rajiv was to live on his own, meeting his family occasionally. The photograph with Indira and Sanjay is dated 24 August 1963, one of the last photographs of them in Teen Murti House.

53

Rajiv's letters to his mother from Cambridge are full of his new experiences: learning to do the Twist, going to concerts, punting and rowing, and managing his finances on a small allowance.

He acquired an ancient VW which had been in an accident. The roof had been badly dented, and Rajiv with his friends straightened it by lying on the seats and kicking the dents out, so that it appeared interestingly corrugated. He went on excursions and holidays with friends, and to parties. He discovered there that he did not like alcohol (he was to remain a teetotaller and non-smoker all his life) and was still shy with girls. But he found pleasure and relief in being an ordinary young man doing ordinary things, not being singled out and scrutinized as the Prime Minister's grandson. This was a carefree and joyful period of Rajiv's growth when he knew complete freedom to be just himself. He emerged from his shell of reserve and formed life-long friendships.

Jawaharlal Nehru died on 27 May 1964. Rajiv was in Cambridge and rushed home to be by his mother's side.

It was a turning point in Independent India's political history, a difficult time with memories still fresh of the traumatic border conflict with China just 18 months earlier. There were growing economic problems as well, and soon there were to be further conflicts, this time with Pakistan. Lal Bahadur Shastri, who took over from Jawaharlal, died of a heart attack in January 1966 in Tashkent, within hours of signing a peace agreement with Pakistan.

In January 1966, Rajiv's mother was elected leader of the Congress Party. On 24 January she was sworn in as India's first woman Prime Minister.

A few months after Jawaharlal's death, Indira moved out of Teen Murti House and into 1 Safdarjung Road. Meanwhile, Rajiv came back to England and his studies at Trinity. He continued to frequent the restaurant where he and his group of friends found a respite from College food – the Varsity: that is where he and I first met, in January 1965. He was just over twenty, and I, eighteen.

It was a moment to which he often referred. In a letter he wrote in 1983 he recalled: "*I was thinking back and remembering how I had first seen you in the upstairs back room of the Varsity and from that moment I had known that you were for me! Funny how things sometimes just click.*" In December 1990, my last birthday with Rajiv, he celebrated that treasured memory: "*To [my wife] who time never changes, who is even lovelier today than when I first saw her sitting back in the corner upstairs in the Varsity – on that beautiful day – With all my love forever.*"

We began to see each other every day. He would cycle over from his digs to mine, and on holidays a group of friends would all pool in for petrol in his battered VW and go out together. When the windscreen broke, we wrapped ourselves up in blankets inside. Sanjay, who had come to England in 1964 to be apprenticed to Rolls-Royce in Crewe, would occasionally come up to Cambridge and join us. Rajiv had always been interested in photography, but from this time onwards he and his camera were seldom very far apart. He began to take pictures of me, and soon I got used to being his favourite subject.

In early March, Rajiv wrote to his mother, "*You never believed me when I said I did not know anybody special... but it was quite true... I think this girl is special. I don't think I am just infatuated, in fact I'm pretty sure I'm not.*"

The following month, he wrote to her again: "*I am quite sure that I am in love with her. Everything seems to point to that. You said that the first girl that you meet is not necessarily the right one, but how is one to know that one will meet one that is in fact more right?*"

Soon after, Rajiv introduced me to his mother, and she readily accepted my place in his life. The communication gap of adolescence which had earlier caused Indira some concern was closed. He wrote: "*I just could not talk to my mother or tell her anything till I met you – then it all became so much easier. I don't know how or why, but it just did.*"

It was now time for me to bridge my own communication gap with my parents. Although we were a close-knit family, they were old-fashioned, and my father a patriarch of the old school. In my milieu, contact between boys and girls was strictly supervised and controlled. My parents were displeased by my departure from their norms.

Rajiv found it hard to understand my dread of confronting them. He wrote to his mother: "*Sonia does not seem to be able to talk to her parents. I can't quite understand what it is. It seems very peculiar. She just does whatever her father says.*" It took all my courage to get them to let me return to Cambridge.

By 1966 Rajiv had joined the Imperial College in London. We could see each other over weekends and holidays, and much of our time was spent commuting back and forth. It was a time of enjoyment and laughter, a period of great happiness in our relationship but also anxiety about the future.

Rajiv was apprehensive about my adapting to India. In one of his letters he wrote to me: "*I want you to go to India and stay with my mother – without me, so that you can see things as they really are and, as far as you will be concerned – at their worst, because I will be away, and you won't have me to rely on. Then you will know the people and the country.... I don't want you to do something without knowing everything that is involved. I will hold myself responsible later if something goes wrong and you are hurt in any way – feelings or otherwise. I won't have to answer anybody but myself and therefore I cannot lie or cheat.*"

In the spring of 1966, Rajiv and Sanjay accompanied India's newly-elected Prime Minister to Paris and the U.S.A. His letters to me over the winter vacation had been full of anxiety about her: "*I had really hoped Ma would not stand as it will be a terrible strain. India is in the worst situation it has ever been in.... I have a feeling most people will want my mother to become Prime Minister. I hope she does not – it will kill her I think.*"

But in another letter he wrote: "*If she did not stand for election...all that we have achieved since Independence would have been lost.*" And in yet another: "*If anything does happen to my mother I will not know what to do. You cannot imagine how much I depend on her for help in any situation and specially about you. You will have it much harder than me. Everything will be new for you and she is the only one who will really be able to help you. I just do not know what I will do if I lose her.*"

Rajiv's concern for his mother was well founded. It was to be a three-year-long battle before she was able to establish her independent leadership. Meanwhile, his adult choices relating to career and marriage were flowing towards a quiet, inconspicuous life.

We were both aware of the realities that had to be addressed. I had to go back to Italy, and my parents had to be persuaded to accept our union. Rajiv was concerned about getting a job soon, so that we could marry. He decided to drop engineering, and began flying lessons, doing odd jobs to pay his way. He was also anxious about his mother struggling alone against difficult odds. He wrote to me in February 1966: "*I have been thinking that I should go back to India to be with my mother as she must be very lonely and has a lot of work to do.*"

It was a year-long haul to a satisfactory resolution of all these problems. In October, Rajiv borrowed his brother's car and drove to Italy (his own had been sold for £4 – a far cry from the Jaguar which he is pretending to own in the picture above left). He had decided to train for his pilot's licence in India and, before going home, to speak to my father about our marriage. In January, he went back to Delhi and soon after began his lessons at the Delhi Flying Club. In between he accompanied his mother on some of her official tours in the country, and his presence cheered and supported her. I stayed with my parents, doing occasional assignments as an interpreter at conferences. We were waiting, holding onto faith and hope, preparing to be together again.

61

62

I arrived in New Delhi on 13 January 1968. Rajiv received his Commercial Pilot's Licence on 23 January and soon after was selected by Indian Airlines as an Apprentice Pilot. He was to start at the Central Training Establishment in Secunderabad on 1 May.

The wedding day was fixed for 25 February, and the engagement a month earlier, on 26 January. The commotion of wedding preparations was soon in full swing: comings and goings, lists, invitations, tailors. I was in a daze at the centre of all these proceedings — terrified each time I wore a sari that it would fall off, wishing only that the hubbub would soon be over. The group photograph was taken shortly after the engagement, and marks the first time I appeared in public as the new member of the family.

Like Rajiv, his mother was very much against the pomp and wasteful display of Indian weddings. She supervised the arrangements with her customary attention to detail, helped by her old friend Padmaja Naidu. The wedding was to be a simple civil ceremony, with two traditional rituals — the *jaimala* or exchange of garlands, and the chanting of *slokas*.

The day before the wedding a *mehndi* [henna] ceremony was held at the house of the Bachchans, where I was staying. I wore a simple *lehnga* [skirt] and *odhni* [veil] given to Rajiv's mother by the Banjaras [gypsies] of Andhra, and the traditional floral jewellery of Kashmiri brides, *phoolon-ka-gehna*.

For the wedding ceremony, both Rajiv and I observed the family tradition in wearing *khadi*: my sari was of pink cotton, his *achkan* [coat] of off-white silk. He wore a pink *safa* [turban], as did all his male friends and cousins. My jewellery again was made of fresh flowers by Mrs. Vakil, who had done the same for her former pupil, Indira, at her wedding. My mother-in-law had chosen, as our *sloka* for the *jaimala*, a verse from the Rigveda which she translated into English for Rajiv to explain to me:

Sweet blow the winds.
Sweet flow the rivers.
May the herbs be sweet to us.
May the nights and days bring us happiness.
May the dust of the earth yield us happiness.
May Heaven, our father send us happiness.
May the trees make us happy with their fruit.
May the Sun endow us with happiness.
May the directions bring us happiness.

The civil ceremony was witnessed by representatives of both families: Vijayalaxmi Pandit, Jawaharlal Nehru's sister; Prof K.N.Kaul, Kamala Nehru's brother; Feroze's sister Tehmina; and my mother's brother Mario Predebon. We signed the register, exchanged rings, and were showered with rose petals by the assembly. Then came the blessing by family members, light refreshments and fireworks orchestrated with great enthusiasm by Sanjay. The same evening I moved into 1 Safdarjung Road. There was a reception at Hyderabad House the following evening, when we met my mother-in-law's wider circle of political associates and friends.

Rajiv and I settled into the tranquil togetherness we had been dreaming of. Each member of the family had an independent existence. Rajiv was flying the Dakota, the plane of his childhood dreams [see page 17], and his brother was absorbed in designing an indigenous car. My mother-in-law as Prime Minister had a full and active life of her own, and did not impose herself on us in any way. We met always over meals — a quick lunch, a leisurely dinner — and moved easily in and out of one another's personal space. The two brothers had many friends and interests in common, as a result of which we spent a great deal of time together. Rarely would one of them leave the house for a drive or a movie or to see a friend without checking if the other were free to accompany him.

When Rajiv was not flying, we were at home or with friends: his colleagues in the airline, or our common friends from the Cambridge days who were in and out of Delhi. He had a Lambretta at first, on which we used to zip around, then a Jawa motorbike which he enjoyed dismantling and cleaning, and later a Fiat. Neither of us cared for parties or belonged to any "set". Rajiv's friends were from varied social backgrounds, and he was perfectly at ease with all of them. He in turn was greatly liked by all who knew him: for his readiness with a joke and a smile, his generous concern for others.

In 1970 our first child was born. I had to spend most of the nine months in bed, because of a miscarriage the year before. Rajiv looked after me with the utmost tenderness. When he was out flying — he was by 1969 Co-Pilot on Fokker Friendships — his mother or his brother would sit with me at mealtimes and do all they could to keep my spirits up. My mother-in-law took a special delight in organizing every detail of the coming grandchild's layette.

When Rahul arrived, Rajiv was ready with his camera at the hospital to record the event. (The photographs on this page are his.) The baby was a little premature and cried a lot, particularly at night. Rajiv was happy to take turns at looking after him. He would get up, clean and change Rahul before and after his feed, and then carry him till he fell asleep.

Soon after Rahul was born, Rajiv became Co-Pilot on the HS-748 (Avro). Over the next ten years, he was to move up to Captain (1972), Commander (1975), Check Pilot (1977), Instructor (1980) and Examiner (1981) before he moved on to Boeings.

The photograph above left was taken by Sanjay and records Rahul's naming ceremony, held on his first birthday. Rajiv was delighted when Rahul, presented with an array of symbolic objects (presumed to indicate his preferences in later life — for example, a pen to suggest learning), chose the toy car. One of his earliest gifts to Rahul was a miniature tool kit.

The photographs of Rahul with me in Italy and with his Dadi [grandmother] and Chacha [uncle] in Delhi were taken by Rajiv.

We used to visit my parents on alternate years, initially, and later once a year. Rajiv learned enough Italian to make himself understood. He enjoyed

the difference in our families — mine being a typical bustling Italian household. However, we were always grateful to return to our placid refuge after a few weeks.

My mother-in-law doted on Rahul. She always insisted that he looked just like Rajiv, though nobody else in the family could see any resemblance. This photograph was taken soon after the electoral victory in 1971 that assured her leadership of the country.

Through all her difficulties she had turned to the family for moral support, and we had shared her concerns and the ups and downs of her political life. Sometimes just a loving hug from Rajiv would rally her spirits.

Our daughter Priyanka's arrival coincided with a time of great political excitement. Rajiv took this photograph of her immediately after she was born. The frames just before this on the roll are of Mujibur Rahman, who had landed in Delhi from London the day before on his way to his newly born country, Bangladesh. It was a euphoric moment, after the tension and anxiety of the preceding months, when the rest of the world had been so indifferent to the plight of India struggling with an influx of about 10 million refugees from what was then East Pakistan.

The photograph of Priyanka at four months was also taken by Rajiv. He kept a photographic record of every stage of his children's growth, highlighting the smallest physical change in them. In Priyanka's Baby Book there is a curl neatly fixed in place with adhesive by Rajiv. When they were babies, I would often see him gazing at them and marvelling at their tiny features.

Rajiv's mother had her office next door at 1 Akbar Road, connected with a short path to her house at 1 Safdarjung Road. But they were two distinct worlds, rarely intersecting beyond the front lawn where she received her morning visitors. The only time her public life spilled over into her domestic sanctuary was when guests came home for meals — normally visiting Heads of State, sometimes journalists, artists and writers. Her need for a smoothly regulated system was strong, and she had her trusted aides, Usha Bhagat and Amie Crishna, who had over years of association come to understand her requirements and tastes. All the same, it was to Rajiv that she would inevitably turn for suggestions or approval on matters ranging from landscaping the garden to supervising the construction of her farmhouse in Mehrauli. Like her, he was a stickler for detail, with a natural appreciation of order, harmony and elegance.

The photographs on this page are also by Rajiv. The picture on the right was taken on 26 January 1972, the day his mother received the Bharat Ratna, India's highest civilian award.

As a father Rajiv was loving and approachable but strict. He could not tolerate any symptoms of what he considered "spoilt brat" behaviour — fussing over food or wasting it, for instance. The children had to finish whatever had been prepared for them, whether they liked it or not and however long it took. He would not allow even his mother to intervene. He had a strong aversion to rudeness or bad manners, and would revert to the old school of punishment — for instance, make the children write 100 times, "I will not bang the door." At the same time, he would nurse them very gently whenever they fell ill, treasure carefully every little thing they made for him, and participate in all their day-to-day activities — reading stories to them, playing games with them and attending all their school functions (the photograph above right shows Rajiv as a runner-up in the Fathers' Race at the school annual day).

"Priyanka is strong-willed, like my mother," Rajiv said once in an interview. Once when she was about four years old and he told her to stand in the corner until she had modified her behaviour, she remained there for two hours; eventually he had to find an excuse to rescue her from her corner. Though Rajiv was very much the centre of authority in the family, he was quite free of gender stereotypes (perhaps because his own mother was such a determined person). He encouraged both his children to be equally fearless and independent.

In September 1974, Sanjay married Maneka Anand. In the early 1970s, his small car project had come under attack from the Opposition parties, as part of a political campaign against his mother, and Sanjay was drawn into politics. After the declaration of the Emergency in June 1975, he joined the executive of the Youth Congress and involved himself increasingly in political matters. This family group photograph was taken in the Kremlin in 1975.

Photography provided a relief from the concentration and long, irregular hours that Rajiv's flying job demanded. Over the years, this interest came to take up more and more of his leisure time. He would experiment with filters and equipment, read magazines and books on the subject, go to exhibitions. The picture on the right shows him conducting a colour experiment with friends who shared his interest. (These pages contain his family photographs. The photographic epilogue on pages 162 – 212 represents a wider selection of subjects.)

In early 1977, Rajiv's mother lifted the Emergency and soon after declared elections. Her government fell, and the Janata government took over. We moved from the PM's residence to 12 Willingdon Crescent. The change was not merely of location. Politics entered our lives directly and palpably as my mother-in-law's political associates, supporters and workers moved freely in and out of the house.

The new government launched a political vendetta against the family, embroiling Rajiv as well. Lies and rumours were planted in the newspapers to suggest that we had amassed wealth by illicit means and were preparing to flee the country to avoid arrest. My mother-in-law and Sanjay, who bore the brunt of the attack, were in fact arrested and put in prison. But even Rajiv was harassed — particularly by the Income Tax Department, where he spent most of his time when he was not flying.

Like everyone else in the family, Rajiv and I were followed by the CBI [Central Bureau of Investigation] wherever we went. The highlight of this ludicrous campaign was in 1978 when we received a phone call to say that several men from the IB [Intelligence Bureau] were searching my mother-in-law's farm with metal detectors. Rajiv was there when they excitedly dug up what they thought was hidden treasure: an old empty tin of 'Dalda' [a popular cooking medium]!

The photograph above shows Rajiv entering the building where the Shah Commission was conducting its investigation into the alleged 'excesses' of the Emergency period. In January 1980, the electorate voted decisively for a return to stable governance, and Rajiv's mother was once more elected Prime Minister. The photograph in the centre was taken shortly before we moved back to 1 Safdarjung Road. Three months later her happiness was crowned with the arrival of Feroze Varun, the son of Sanjay and Maneka, who immediately became the darling of our household. Rajiv took the photograph below on the day Sanjay brought his son home from the hospital.

On 23 June 1980, while we were in Italy visiting my family, Sanjay died in a plane crash, leaving a widow of 23 and a three-month-old son. For Rajiv it was the loss of his only brother with whom he had shared so much of his life. For my mother-in-law it was a devastating blow: she had lost not only a beloved son but her most trusted political aide.

As is customary in India, Rajiv, being the eldest (and now the only) son, would have to meet people who came in droves to offer their condolences to his mother and the family: ordinary people, party workers from all over the country, groups from his mother's and brother's constituencies. The groups soon became delegations; the demands began to mount on Rajiv to enter politics. He held them off for almost a year, hoping that the pressure would subside. Meanwhile, he continued with his flying.

Flying had been Rajiv's passion all of his adult life. For most of his 13 years with Indian Airlines, he had flown propeller-driven DC-3s, F-27s and HS-748s. In January 1981, he qualified as a co-pilot on Boeings. But for him the long-awaited excitement of flying jets was to last a short time. He resigned from the airline on 5 May 1981 to contest the Amethi bye-election. Once he had made his commitment to politics, he never looked back.

THE LIFE
THAT CHOSE
RAJIV

The Amethi election was announced for June 1981, and Rajiv was nominated the Congress Party candidate. He had to make a great effort to overcome his natural inhibition about being the focus of attention. For someone as private as he was, it was initially an ordeal to face cameras and deliver speeches. In time, he became a practised and even polished speaker. He either spoke from notes or, if required to deliver a formal address, prepared a speech. In either case, he thought deeply about what he wanted to communicate and took pains to find the precise words in which to clothe his ideas. The five-volume selection of his speeches and interviews between 1985 and 1989, over 500 in number, is more than a record of the issues that confronted him as Prime Minister. It is a narrative of his thoughts and feelings as the leader of his country, and of his political and philosophical concerns.

Amethi had been designated as a constituency in 1967. In 1980 Sanjay had been elected Member of Parliament from there. It was next door to Rae Bareli, the constituency of Rajiv's father and later his mother. In 1981 she joined Rajiv on 11 June for a day during his campaign (photograph above left).

The election was held on 14 June 1981 and the result was announced the next day; Rajiv won handsomely and on 17 August 1981, just before his 37th birthday, took his pledge as Member of Parliament in the Lok Sabha, the House of the People.

Amethi was a backward area of eastern Uttar Pradesh. It lacked basic amenities such as roads, drinking water, schools, medical facilities. Among the first things Rajiv did was to draw up detailed plans for its development. He maintained a data-base on Amethi in his computer and closely monitored the progress of work in his constituency. His method of working — practical, thorough, efficient — was ingrained in him from his professional training and experience. It was a new and different style in the world of Indian politics.

(Facing page) As a new entrant into politics, Rajiv was eager to learn. (The picture above was taken in his office on Akbar Road.) He began to participate in the programmes of the Youth Congress. The picture on the left, centre shows him donating blood at a Youth Congress function held on Sanjay's death anniversary; that on the left, below was taken at the North-Eastern Regional Youth Congress convention.

The picture on the right was taken in Bangalore in December 1981, at the National Conference of the Youth Congress. This was Rajiv's first major political meeting, where he was appointed a member of the National Council. He initiated leadership and training camps to give the organization a progressive outlook and prepare promising members for political responsibility.

85

98

Rajiv had much to reflect on at this formative stage in his political life, the beginning of his engagement with the political system. As "*an apprentice in the great school of politics*", to use his own words, he was asking questions, observing and examining a complex system. What he brought to this process of enquiry, apart from his commitment, was a sound pragmatic bent of mind. His own description of what he regarded as the scientific temper is evocative: "*ordered thought, logical thinking... subject to intuitive insight... a probing, restless mind which takes nothing for granted... a mind that refuses to acquiesce in anything shoddy... that insists on bettering even the best.*"

It was during this intensely absorbing phase that many of his ideas took shape, which were later expressed in policies and initiatives when he became Prime Minister.

87

When the Congress government took office in 1980, it found that India was committed to hosting the next Asian Games in November 1982. Virtually no work had been done to organize the Games. Time was very short and India's reputation was at stake.

Rajiv took on the responsibility of making sure that the deadline was met and that the Games were a success. Morning and night, he would be out at work checking every detail, encouraging his team. In the space of 22 months, several modern stadia were designed and constructed to international specifications.

"*The Asian Games was a window for the world to see what India is capable of doing when we really mean business,*" he said later, acknowledging the help of "*every single person that was involved – from the labourer to the Cabinet Minister*".

My mother-in-law wrote to her friend Dorothy: "*Rajiv has done a magnificent job with our Asiad.... Many have co-operated, working hard and with dedication but watching it all, I have no doubt that it is Rajiv's own effort, his organizing capacity, aim at excellence, and concern for the minutest detail that enabled us not only to be ready on time, but, as we are told by the Heads of the various international Sports Associations who have come, to attain international standards in our constructions and all other arrangements. The opening ceremony was spectacular.*"

(Facing page) In another letter to Dorothy Norman written in August 1982 my mother-in-law reflected: "*Yes, I am quieter, sadder. Yet is it hardly fair to want more? Life has given of its fullness to me, in happiness and in pain. How can one know one without the other?*"

Her anguish following the loss of her son had recently been compounded by Sanjay's widow's decision to leave our home. My mother-in-law had carried her burden with dignity and in silence. She drew strength and comfort from Rajiv's supportive presence in her work, and from us at home.

89

06

Rajiv was by this time reporting to his mother on Congress Party affairs. He had become one of the General Secretaries of the party in 1983, and was touring the country widely on party work. He was discovering much that was wrong and in need of change, but also much that was good and in need of encouragement. He was reaffirming within himself the political values that had shaped the country — the legacy of Gandhiji and Jawaharlal Nehru.

"*Two basic principles have informed our system of planning: self-reliance and priority to the poor....*

"*We look upon self-reliance as much more than the path to economic development. We look upon it as encompassing the path to nation-building.... Economists argue that our stress on self-reliance has resulted in slower growth than might otherwise have been possible. It is true that aid, investment, technology and trade might have come our way more easily and more abundantly if we had opened our doors wider and given ourselves over to the more wealthy, the more powerful, the more economically and technologically advanced.*

"*But the experience of others, whether in Latin America, Africa or even parts of Asia, would appear to indicate that soft options give only an illusion of faster growth. Very quickly, the non-self-reliant path leads to debt traps and demeaning dependence. The growth process is disrupted. The race eventually goes to the steady....*

"*The poor constitute the vast majority of our country. They constitute the majority of even ethnic, linguistic and religious group in the country. Poverty cuts across every category. In making the poor the focus of our planning, and in ensuring that the poor of any one ethnic group are neither favoured nor discriminated against, we have pressed planning into the task of uniting the nation and given our people a common stake in political stability and economic progress.*"

The pride Rajiv felt in becoming part of India's political traditions was tempered, however, by the knowledge that much, much more remained to be accomplished.

Rajiv was addressing a public meeting at Contai in Midnapore district on 31 October 1984 when he was told that his mother had been injured (photograph on facing page, above). He drove at once to Kolaghat where a helicopter picked him up and brought him to Calcutta. On the flight back to Delhi the news that his mother had been assassinated was confirmed. He was sworn in as Prime Minister the same evening.

Rajiv's first concern was to stem the violence that was beginning to break out: "*Nothing would hurt the soul of our beloved Indira Gandhi more than the occurrence of violence in any part of the country,*" he said in a broadcast to the nation immediately after his swearing in. In another broadcast on 2 November, he warned again: "*While hundreds of millions of Indians are mourning the tragic loss of their leader, some people are casting a slur on her memory by indulging in acts of hatred and violence.... This must stop forthwith.*"

Rajiv's mother was cremated on 3 November (facing page, below). She had wanted her remains to mingle with the high mountains she had loved (centre, right). "*With the scattering of her ashes in the Himalayas will end Indira Gandhi's earthly journey,*" Rajiv said. "*But the nation's journey continues. Let us walk together, stout of heart and purpose, firm in step.*" The spot where my mother-in-law was assassinated (below, right) is now a national pilgrimage site visited by more than 1.5 million people a year. The house where she spent close to twenty years of her life is a museum.

94

Once terrorism became a fact of India's public life, the responsibility for the PM's protection had been vested in a Special Task Force drawn from the para-military services. The system had failed. A professional force, the Special Protection Group, was set up in its place as a specialized security unit. Security was not a perquisite of office but a necessity; the threat to Rajiv's and the children's lives was from 1984 onwards real and continuous.

Rajiv had been inducted to office at a time of crisis. The five-year term of the Congress government was almost over, and a general election was due. Rajiv decided to go ahead with it and seek a mandate from the people. He went from state to state explaining how important it was for the country to remain united under a firm and purposeful leadership. "*There is only one India. It belongs to all of us,*" was his message.

He toured his own constituency at the start of his campaign on 20 November and at its end on 19 December. I went from village to village in Amethi to canvass support for him. By now I had become a regular visitor there. I knew the people and their problems, and I no longer felt a stranger amongst them.

The 1984 election gave the Congress 405 seats out of 542 in the Lok Sabha. It was the highest the party had won in any election. In his broadcast to the nation, Rajiv said: "*You have given my party and me your confidence in overflowing measure.... And how can we prove worthy of it? Only by working for you with unremitting faith and humility, summoning all our reserves of strength and energy, being as unsparing with ourselves as you have been generous with your trust.... Great tasks await us and we should approach them in a spirit of togetherness. United, there is no challenge that we cannot meet.*"

He saw his task as one of steering the country through rapid modernization within the framework of continuity: "*In trying to live up to our responsibilities, this Government will scrupulously follow the basic approach and principles bequeathed to us by Jawaharlal Nehru and Indira Gandhi. Like them, we shall be dynamic in our responses to the changing context.*"

Rajiv was sworn in again as Prime Minister on 31 December 1984, this time with an unprecedented mandate. He was just past 40, the youngest Prime Minister India had known.

He shouldered his new responsibilities with a sense of urgency; the country had been through a terrible trauma. "*For me there was no time for mourning, only time for action. I threw myself into restoring confidence, restoring security, restoring friendship and brotherhood between communities that have lived together for centuries,*" he was to recall.

The photographs on this page show him after his election as the leader of the Congress Party, at his swearing in and being congratulated immediately after. The one on the facing page appeared on the cover of *Leaders* magazine in 1985.

Rajiv started work immediately on all the priorities his programme had listed: electoral, economic and administrative reforms, action on the environment, a new education policy, measures to improve ties with India's neighbours. "*We stand for a politics of conciliation, not of confrontation, of solving problems by sitting down across the table... preventing pressures from increasing to a point where our system will not be able to sustain them,*" Rajiv declared. Soon after the state assembly elections, he made a visit to Punjab (centre); high-level discussions had already begun with the opposition leaders of the state, and of Assam. "*Our road [is] long and arduous,*" he cautioned; but he was full of hope and enthusiasm: "*Together we will share the burden and the ecstasy of building our India.*"

Four decades earlier, Jawaharlal Nehru had said to a resurgent Asia: "*We meet together, we hold together, we advance together.*" Rajiv brought this approach to India's relations with her immediate neighbours. When in June 1985, a cyclone devastated Bangladesh, he and Sri Lankan President Junius Jayawardene, who was in India at the time, spontaneously flew to the affected areas and extended help to the victims — "*an expression of the growing spirit of solidarity among the countries of South Asia*", as Rajiv reported to Parliament. Rajiv was energetic in promoting India's image overseas as a proud, independent country with a rich past and immense potential. "*The success or failure of a country's foreign policy depends on the respect the country carries in world organizations and among the other countries in the world.*"

Apart from making India's voice heard in the world, he aimed to get technological know-how and encourage investment in the Indian economy. "*We offer political stability, consistent policies, a wide industrial base, a very large trained manpower, access to various markets and a very good past record of dealing with foreign companies.*"

In May 1985, Rajiv made his first State visit, to the USSR. In the photograph, General Secretary Gorbachev offers him the scent of freshly plucked lilac. The rapport between them was to be an enduring and fruitful one. The same summer, Rajiv went on a six-nation tour. It began with a visit to President Mitterrand and the inauguration of Festivals of India, in France and USA. He saw these Festivals as people-to-people contact, "*communication at a most important and fundamental level*", which would lead to an understanding and appreciation of India. Such cultural exchanges in India and abroad were a feature of Rajiv's term as Prime Minister.

"*We have so much to secure for our own people and so much to give to the world,*" he believed. "*Our composite culture rejects nothing that is desirable, accepts all that is enriching, is tolerant of the different hues and colours of the human experience, has the self-confidence to interact with that which has its origins elsewhere, and the open-mindedness to recognize that we have much to learn from others as, indeed, they have to learn from us.*"

Rajiv symbolized the new generation in his country — bold, energetic, innovative. "India is an old country but a young nation," Rajiv told the US Congress, "and, like the young everywhere, we are impatient. I am young, and I too have a dream. I dream of an India — strong, independent, self-reliant and in the front rank of the nations of the world in the service of mankind. I am committed to realizing that dream through dedication, hard work and the collective determination of our people."

Rajiv had met President Reagan before, in 1982, and they communicated with immediate ease and informality. India's relations with the USA improved significantly in the atmosphere of trust that was established, bringing the country concrete benefits such as trade, technology and an improved security environment. Meeting the National Press Club in Washington, Rajiv impressed media veterans by the quiet confidence with which he fielded their most tricky questions, and charmed them with his spontaneous wit.

Rajiv had said to his countrymen: "*From time to time I shall share with you my ideas, my hopes, my struggles. But even more, I want to listen to you, to your difficulties, your ideas, your hopes.*" He began to travel through the country: "*...My first tours were in the Adivasi [tribal] areas. I made an effort to go to the most backward areas... the poorest villages, the smallest huts, and see what their problems, their difficulties [were].*" These pictures were taken during the first few of his rural tours to Madhya Pradesh, Bihar and Orissa in July 1985.

"*I see a lot of love in people's eyes, friendliness, trust and perhaps most of all hope,*" he was to say of his experiences. "*One realizes the tremendous energies that are available, the tremendous potential that is there in our country. At the same time one sees the inability of a very large section of the people to make use of that because of their poverty...*"

Rajiv's extensive tours became a hallmark of his prime ministership. They were a fertile source of inspiration for his ideas on eliminating his country's "*old enemies – poverty, unemployment, disease, ignorance*".

101

"It takes much more guts and courage to be non-violent than it takes to be violent," Rajiv believed. On 24 July 1985, intricate negotiations with the political leadership in Punjab culminated in an Accord, signed with the President of the Shiromani Akali Dal, Sant Harchand Singh Longowal. The photograph below left records the event. Within a month, the terrorists had sabotaged the Accord by killing Sant Longowal. Punjab was to remain the most intractable of the country's problems, but Rajiv's approach was consistent: "We stand ready to talk to anyone who accepts the Indian Constitution and gives up violence."

He upheld this stand while negotiating peace settlements in other areas of conflict: Assam, Mizoram, Tripura, Darjeeling. In the elections that followed the Accords, he put the country's unity decisively before his own party's interests: "It does not matter who wins and who loses. What matters is that the lamp of democracy is not extinguished: what matters is that India wins."

(Facing page) "In the last few weeks, I have travelled from the hills to the desert of Rajasthan. The problems of the poor were identical. In the cities too I have visited the hutments of the poor. The purpose... was to find how we could improve our programmes and streamline the administration to ensure that the poor people of India are able to receive full benefits from these programmes." Rajiv would frequently depart from pre-arranged schedules to come face to face with the reality behind the official screen. Over a period of time, he gained a sound appreciation of the strengths and shortcomings of the government's policies and its functioning. "When we try to get the feedback on the implementation of these programmes through Government machinery, whether Central or State, we get misleading information. Information gets distorted on the way. The truth gets diluted....The only way is to formulate programmes [so] that no bungling is possible."

From his travels arose Rajiv's concept of differentiating the country into agro-

The photograph of Rajiv in a village classroom was taken in July 1985 on his tour of tribal areas of Madhya Pradesh.

Rajiv saw education as a process continuing beyond the classroom, a way to cultivate "an awareness of the world, a responsibility towards other human beings, towards nature, self-confidence to take decisions, to brave hazards and to face consequences."

The New Education Policy was formulated after more than a year of discussion and debate with educationists. Pragmatic in its orientation to jobs and skills, it was a major step to breaking the colonial educational mould. It also gave special opportunities to girls and to other disadvantaged groups.

Rajiv was aware of the urgent need for more schools, and better schools. The Navodaya Vidyalayas, model schools for gifted children, based in the rural areas, were designed to make the best education available to bright youngsters from the poorest sections — children of the Scheduled Castes and Scheduled Tribes. More than 200 such schools were set up around the country. That was one aspect of the "quantum jump in the quality of education" that he was trying to stimulate.

102

economic zones: "*For the first time, our planning process will be tuning in almost district-wise to see what is required to be done for the farmer, for the farm labour, for the weaker sections in the area, to help them with their agriculture.*" He firmly maintained: "*If we find that a model does not adapt to our system, we must develop a new model. It is not good enough to keep on walking along the same beaten path.*"

Many of Rajiv's tours took him to the far outposts of the country. He never missed an opportunity to spend time with the men and women guarding India's borders, whether in the deserts of Rajasthan, the snows of Ladakh, the deep valleys of the Northeast or along her coastline.

Science and technology were the basis of Rajiv's concern with bringing India into the 21st century. He inspired scientists and encouraged innovation. (The photographs left and centre show him in a forensic laboratory.) But it concerned him that science and technology were confined to the laboratories, not making an impact on poverty.

His singular contribution to grass-roots modernization was the Technology Missions set up for specific areas: drinking water, literacy, immunization, milk production, telecommunications and, later, oilseeds.

"*Whenever the environment is damaged, a bit of India dies,*" Rajiv warned. From the time he was a boy in school, long before ecology had become a widespread concern, Rajiv's mother had made him sensitive to these issues. In his first broadcast, he had announced the setting up of the National Wastelands Development Board and the Ganga Authority. The picture below left, taken on a tour of Kerala, shows him in the Silent Valley, the last surviving tropical rain forest in India, preserved as a sanctuary through his mother's efforts. During this visit in September 1985 Rajiv had been unable to hold back his indignation when he found that some trees and bushes on both sides of the road had been cut down by security personnel. The pictures on the facing page are of the same tour, and show Rajiv greeting tribal women and visiting a fishing village.

104

"There is only one group which really knows what is happening at the grassroots," Rajiv concluded from his tours of rural India: "The people at the grassroots." The monitoring of development schemes, he perceived, had become "an elaboration of statistical tables furnished by the very officers whose work is supposed to be monitored, with little or no two-way communication between those responsible in the field and those who sit in far-away air-conditioned cubby-holes."

He had promised the electorate a new administrative work ethic, "result-bound and not procedure-bound". This quest would bring him in his second year in office to declare 'Responsive Administration' as a priority, and to pursue it tirelessly through his term.

At the same time, Rajiv understood the psychological and sociological effects of the existing system: "The people's expectations have risen dramatically. They are not content to acquiesce in their lot. They demand — and rightly so — that we give them opportunity and openings. But, because the responsibility for development does not lie in their hands, their expectations from the development process are not linked to an appreciation and awareness of the constraints of resources, the hard choices to be made, and the hard work to be undertaken."

Rajiv saw increasingly that development could succeed only where the people were encouraged and enabled to play an active role in planning and implementing programmes designed for their benefit. He commended individual initiative and community participation wherever he encountered it — particularly when it involved women.

"*For genuine progress to be achieved in our countries, we need peace in the world and stability in our region,*" Rajiv often emphasized. On this occasion (left), in September 1985, he was in Bhutan, the mountain kingdom on India's northern borders. India's relations with Bhutan exemplified Rajiv's approach to her neighbours. South Asia's biggest nation and its smallest evolved bonds based on trust and on common interests. (He was among the founders of the South Asian Association for Regional Cooperation, launched in Dhaka ten weeks later.)

"*In a troubled world, India has a role to play because of its history, its geography and its faith in peaceful coexistence,*" Rajiv believed. On his first State visit, to Moscow in May 1985, he had listed some of his concerns: "*The continued denial of the legitimate rights of Palestinians, the blatant practice of Apartheid and aggression in South Africa against African peoples, the denial of the rights of the Namibians, the efforts to frustrate the functioning of governments in Latin America and the continuing armed conflicts in South-West and South-East Asia.*"

(Facing page, above): "*All gatherings of leaders of nations today have three principal concerns,*" Rajiv told the Commonwealth Heads of Government meeting in Nassau in October 1985: "*The challenge of world poverty, the avoidance of a nuclear war and the elimination of racism. Our success is measured to the extent we have contributed to these three tasks which together will help to evolve a better world order.*"

He pressed Great Britain vigorously to take a stand on comprehensive mandatory economic sanctions against South Africa: "*Let not the Commonwealth be charged with cowardice in action and bravery in words,*" was his challenge. "*Namibia's bondage continues. There is no end to repression, bloodshed and suffering.... We shall be failing ourselves if we persist in this passivity.*"

(Facing page, below): Rajiv's first address to the UN on 24 October 1985 called for a crusade for peace, freedom and equality: "*On this, the fortieth commemorative year of the United Nations, should we meekly accept the fact of the world's divisions, dangers and injustices?*

"*Terrorism has become a major challenge of our times,*" he pointed out. "*It has assumed new forms. Violent groups use modern communications and the media to dramatize their demands. Their contempt for human life borders on barbarism. Violent acts by individuals or groups is reprehensible enough. No less reprehensible is violence by states or by official agencies. Such unilateral acts can only spell anarchy for the international order.... Civilization has meant the progressive evolution of norms for interaction between individuals, societies and nations.*"

The day before, he had defended India's non-aligned stand to the US Council of Foreign Relations: "*We have known the pain and humiliation of colonialism, as well as the joy of liberation. It is natural, therefore, that we have consistently stood with the oppressed peoples in their struggle to shape their own destinies in freedom.*"

107

"*We may make mistakes if we experiment,*" Rajiv often said, "*But we will certainly get nowhere if we don't.*" In the five years of Rajiv's premiership, he initiated far-reaching economic reforms, cut back controls and red tape, and began to open up the economy to domestic and global competition.

He believed that the role of the state was "*to liberate and direct the productive forces*" of society so as to build a strong, efficient and technologically advanced India. Major policy initiatives in agriculture and industry during his prime ministership were directed towards increasing productivity, reducing costs and improving quality. Rajiv's government encouraged entrepreneurship and relaxed curbs on growth, so that the economy registered the highest ever rate of growth in four decades.

He demanded improved performance from both the public and the private sectors: "*We cannot afford to subsidize our industries at the cost of the poor.*" But he made substantial outlays in public sector undertakings, as well as in irrigation and power. The picture above was taken at the site of the Thein Dam in Punjab.

A year had gone by since my mother-in-law left us. We missed her encouraging and protective presence, her warmth and wisdom. We had witnessed her struggle, but now that Rajiv was Prime Minister, he experienced the magnitude of the responsibility she had carried and the difficulties she had faced.

On her first death anniversary, we paid homage at the spot where she had been assassinated and at Shakti Sthal, the memorial built where she was cremated. Rajiv addressed a public meeting (left) at the India Gate lawns.

(Facing page) Visiting Japan, Rajiv said to Prime Minister Nakasone, acclaiming the achievements of "*the first Asian country to assimilate the new scientific knowledge*" and applauding its innovative genius: "*Your production and management methods are studied with admiration.*" He voiced a concern equally important to him: "*We*

also admire Japan's resolve to preserve its traditions of spirituality, tranquillity and beauty."

Urging Japan to lend its technological skills to India's modernization drive, he pointed out the heroic scale of his country's struggle: *"You had not to reckon with the calamitous consequences [of being colonized].... At independence, India had to import food to feed 350 million people; today we are self-sufficient for a population of 750 million people. In 1947, we did not produce even lathes; today, we build our own fast breeder reactors and launch our own satellites. When freedom came, we had only 24 million children in schools; today we have 128 million. Four decades ago, only 4,400 science students graduated from our universities; this year, there will be 73,000. When planning began, our rate of saving was only 10 per cent; today it is 23 per cent.*

"India, comprising one-seventh of the human family, has accomplished this transformation within a democratic framework."

"Disarmament is not only a mechanical process of reducing stockpiles but a mental process of looking upon the world as one family," Rajiv declared in his campaign for world peace.

In December 1985 he received the Beyond War Award (left) presented to the Six-Nation Five-Continent Initiative that was campaigning for nuclear and general disarmament.

At the Summit held in New Delhi in January, he had pointed out: *"The dangers have increased of computer errors, systems failures, accidents, and misjudgements at lower echelons to whom responsibility is inevitably delegated. There is besides, the new danger of nuclear terrorism and blackmail."*

At the Award presentation ceremony, he stressed the message that his country offered to the world: *"We believe that nations, big or small, powerful or apparently weak, can and must learn to live together, in mutual recognition and trust. We believe that weapons of collective suicide cannot be guarantors of a durable peace."*

109

"*Material progress is necessary. We must have it. That is why we are giving this thrust in India for science, for technology, for development.*" But, while guiding his country towards modernization, Rajiv felt it was imperative not to lose sight of all-round human development: "*The relationship between the individual and society is being redefined in the hearts and minds of every Indian across the length and breadth of the country. The signposts of the past are disappearing fast as we drive into the future. There is much in the burden of the past that we must discard. There is much more that we must preserve.*"

The picture above was taken at the World Kannada Conference in December 1985. At all meetings of educationists, scientists, planners, Rajiv spoke of these deeper concerns: "*Progress poses its own challenge – to the mind and spirit, to morale and perhaps most, to morality. Some respond to material progress by becoming crass materialists. Some others respond more dangerously. They give simple answers to very complex problems, simple answers to be*

found through fanaticism, fundamentalism or communalism."

(Facing page) One of Rajiv's earliest initiatives had been the Anti-Defection Bill — "*the first step towards cleaning our public life,*" as he described it. It was a clear signal of his intentions. Now, at the end of his first year in office, he was to make a clear statement of his political agenda.

Rajiv's speech at the Congress Centenary meet in Bombay was a call to Congressmen to dedicate themselves again to the vision of the great patriots who had given the party its identity and brought it to lead the country. It was a historic speech — the fervent words of a young man fired with ardour to serve a great cause. It glowed with his burning desire to rally his compatriots to the goal of renewal that he outlined. All he strove for in his five years of work was in the charter he presented: "*We have to revive this tradition to fight for the poor and the oppressed. Only by doing so shall we gain*

the strength to create the India of our dreams.

"*Our administrative machinery is cumbersome, archaic and alien to the needs and aspirations of the people. It has successfully resisted the imperative of change. It must learn to serve the people. It must become accountable for results. We need structural changes at all levels. We shall have them.*

"*The power to shape their own lives must lie with the people, not with bureaucrats and experts. Experts must help the people. Vibrant village panchayats must discuss, deliberate and decide the choices to be made.*"

"*Our ideology of nationalism, secularism, democracy and socialism is the only relevant ideology for our great country,*" Rajiv declared. He castigated the elements in his Party who were reducing it to a shell — "*the brokers of power and influence*"— and he called the Party to its task: "*The revitalization of our organization is a historical necessity.... It falls to us to work for India's greatness. A great country is not one which merely has a great past. Out of that past must arise a glorious future.*"

111

Our new home at 5 Race Course Road was our only island of privacy in a life which had otherwise become completely public. Besides our friends and relatives, we occasionally entertained Heads of State or Government with whom we had a personal relationship. The family group picture was taken in Rajiv's study. The other shows him with our parrot Gumbo. The pictures on the facing page were taken on a brief year-end vacation in the tiger sanctuary of Ranthambhor. My parents were also with us.

"The core of the problem in our development process is the gap between what India can do and what India is doing," Rajiv said in Parliament at the start of his second year in office. He had brought in electoral reforms, initiated major policy changes, instituted measures to galvanize the administration. But he knew there were no shortcuts and easy solutions. He voiced his concern about inefficiency in the public sector. "We need a strong and vibrant public sector... not one that drains the wealth of our people."

He warned against the danger of communalism, "the tool that has been used historically to weaken our country": "It is only with tolerance, with harmony and with concord that we can really move ahead," he said, of his government's decision to safeguard the guarantees given to the minorities at the time of Independence. He spoke of his plan to set up more zonal cultural centres and to have an annual cultural festival in the capital, "which will project cultures from all parts of the country so that they may mingle and intermix".

Over the next two years, Rajiv was to be preoccupied with the consequences of long-term environmental damage. It had become a critical problem: "*Our deserts are spreading. We have terrible problems of deforestation, soil erosion, of water-logging and soil salinity and alkalinity, floods and droughts,*" he said. He toured the affected areas extensively, personally monitoring relief operations. These pictures show him in early 1986 visiting drought-hit areas in Gujarat, Andhra Pradesh, Rajasthan and Maharashtra: "*This year we have spent over a thousand crore rupees on droughts and floods. How much work could have been done with that... if it had been utilized positively instead of... as an emergency measure.*"

"*There is no country richer than ours in the most precious asset of humankind – the human resource,*" Rajiv was convinced. "*The glory of India is everyone – the rich, the poor, the illiterate.*" He did not equate literacy with education, or intelligence with wisdom; he believed that however poor and unlettered, his countrymen had a tradition of "*deep contemplation... deep understanding and real knowledge about the comprehensive goals of life.*" But, he also pointed out, "*It will not do to romanticize life in our villages. Life there is hard. Life there is exacting. Life there is, in many ways, exploitative and oppressive.*"

The photograph on the left was taken on one of our tours to Amethi. To the people of his constituency Rajiv was their 'Bhaiya', their brother, accessible and concerned in spite of his many responsibilities as Prime Minister.

(Facing page) Africa's fight for human dignity and freedom was a cause that stirred Rajiv, as it had his mother and his grandfather. He spoke out passionately in all global forums against racism: "*Apartheid is an abomination. Apartheid rests on inhumanity.*" In May 1986, he visited Zambia, Zimbabwe, Angola and Tanzania, and was host in Delhi to Sam Nujoma of Namibia. Rajiv was the moving spirit in setting up the AFRICA Fund (an acronym for Action For Resisting Invasion, Colonialism and Apartheid) at the Non-Aligned silver jubilee summit in Harare later in 1986. He was made Chairman of the AFRICA Fund Committee which raised half a billion dollars for the Frontline States and liberation movements in Africa. "*To temporize with apartheid is to compromise with human decency,*" he declared at a meeting of the Fund. The pictures here are of Rajiv with Presidents Kenneth Kaunda of Zambia, above, and Robert Mugabe of Zimbabwe, below.

"*India is indivisible but it contains the frictions of a continent,*" Rajiv explained in an address to an American university. "*Yes, [it] does have problems with its languages, its communities, castes and ethnic identities and religions. Only democracy is flexible enough to accommodate such pressures.*"

The Northeastern hill states of the country had a long history of disaffection, and in some parts there had been conflicts. Rajiv travelled extensively in these areas, and a bond grew between him and the people.

In June 1986, the Mizoram Accord put an end to 20 years of strife in the state. Once again, Rajiv's faith in patient negotiation enabled the country to overcome a long-standing problem. He received a warm welcome in Mizoram (left, above).

"*If nuclear weapons denote the world's death-wish, our Movement represents humanity's will to survive,*" Rajiv said at the Six-Nation Disarmament Summit at Ixtapa in Mexico. It was on the 41st anniversary of Hiroshima. "*Nuclear weapons make no distinction between the aggressive and the peaceful,*" he pointed out. "*It is, therefore, our duty as non-nuclear weapon states to exert unremitting pressure on the nuclear weapon powers to negotiate and to disarm.*"

The stand that India took on these key issues came from Rajiv's conviction that his country had a profound message to give: "*The culture of India embodies those qualities which have enabled us to survive and flourish as a civilization over five thousand years. It has given us the strength to endure adversity and to maintain equanimity in success. It has taught us tolerance and compassion, detachment, a love of our fellow beings, a sense of oneness with all humanity. It has taught us to respect the moral and spiritual values of others and rejoice in the great and glorious diversity of the world. We must retrieve, preserve, cherish and develop all that is noble in our heritage. We must also share it with our well-wishers and our friends.*"

In August 1986, Rajiv flew over the flood-affected areas of Andhra Pradesh: "*Our experience has shown that neglect of the environment is at the cost of development,*" he was to say. The demand for relief had increased three-fold in less than five years. He was convinced that increasing the awareness and participation of the people was the key to solving this problem: "*I have seen with my own eyes how great schemes of afforestation came to nothing when the saplings planted soon withered from lack of care.... But I have seen too that wherever the villagers were associated with the programme such things have not happened.*"

The photographs on the right, centre and below, record two moments on 2 October 1986. That morning, an attempt was made on Rajiv's life. As we walked into the Raj Ghat memorial for the traditional prayer meeting on Gandhiji's birth anniversary, a shot was fired in our direction. Rajiv immediately asked one of his personal security officers to investigate. We were told that the noise was that of a scooter back-firing. Rajiv and I sat through the prayer meeting. As we emerged from the memorial, more shots were fired. People walking with us were hit by pellets; the Personal Security Officer to my right was grazed on the forehead. From Raj Ghat we went on to former Prime Minister Lal Bahadur Shastri's memorial, a short distance away, and then on to the rest of the day's programme. It was apparent that there had been a security failure once again. It was after this incident that the security system was tightened and upgraded.

Rajiv continued with his day's busy programme. It included a visit to Sewagram, to commemorate the 50th anniversary of the ashram set up by Mahatma Gandhi in Maharashtra. Rajiv is seen here with venerable Gandhians, spinning the *charkha*, the symbol of Gandhiji's political philosophy.

It wasn't only in India that Rajiv took cheerfully to local or tribal customs. During a visit to Australia and New Zealand in October 1986, he was greeted in Rotorua with a hongi, the traditional Maori greeting. He told his hosts in Auckland: "Your enduring image in the minds of our people is that of a good friend, warm, affectionate, informal."

India played host to the second SAARC summit, held in Bangalore in November 1986. New areas of co-operation, including the mass media, cultural exchanges sports and tourism, were identified. The organization was given an institutional structure, and work was started on areas such as preventing drug trafficking and abuse.

At the first meeting of SAARC in Bangladesh, Rajiv had hailed the "act of faith" that lay behind this newly-born regional grouping: "We emerged from two centuries of colonial oppression as free, independent, equal countries. We each have our personalities, our particular characteristics, our nuances of culture and spirituality. We vary in size. Our endowments differ. Our paths to development are our own. Our political systems are not all the same. But we are, all of us, animated by a shared spirit of South Asia. Among our peoples, there is an immediate recognition and familiarity, a sense of shared values, fellow-feeling and brotherhood. It is upon this natural goodwill that we build.

"India welcomes the diversity of our region. We affirm the sovereign equality of the seven States of South Asia. We have much to learn from one another and much to give. We have a profound faith in peaceful coexistence. We are confident we share these beliefs with all our partners in the region."

General Secretary Mikhail Sergeyevich Gorbachev and his wife Raisa visited India in November 1986. The Delhi Declaration was the outcome of the exchanges between Rajiv and Gorbachev. Its central theme was a statement from the core of India's civilization: "*In the nuclear age, humanity must evolve new political thinking, a new concept of the world that would provide credible guarantees of survival.... Philosophies and policies based on violence and intimidation, inequality and oppression, and discrimination on the basis of race, religion or colour, are immoral and impermissible. They spread intolerance, destroy man's noble aspirations and negate all human values.*"

Kashmir had always been a sensitive issue demanding sensitive handling. In November 1986, Rajiv came to an understanding with Farooq Abdullah, the leader of the National Conference, and visited the state the following month. (The photograph in the centre shows Rajiv in the jeep crowded around by supporters in the Valley during this visit.) Soon after, elections brought a popular government to power in Kashmir.

"*The voice of the people, their felt needs, their aspirations, their priorities must become the building blocks of the edifice of planning. We must put an end to planning from above. We must put an end to priorities being conceived and decided at ethereal heights, far removed from the realities of the ground. We must put an end to paternalistic planning. We must initiate a process of people's planning.*"

Rajiv had set up the Island Development Authority to deal with the special problems of India's island outposts. He insisted that the official agencies responsible for development make the effort to go there to gain a first-hand understanding. At the end of 1986, the annual meeting of the Authority was held at Port Blair in the Andamans. The picture shows Rajiv being greeted enthusiastically by the islanders.

121

"1987 was a year of persistent challenge and determined response, a year of achievement in the face of great difficulties," Rajiv was to comment in Parliament. He said later that year, referring to contemporary political currents, "The election of 1984 gave us a powerful mandate for change. I am carrying out that mandate in the face of adamant opposition from the vested interests whose apple carts are being upset. Our judiciary, administration, legislatures and political parties have an impressive history going back several decades. But, all too often, they have not kept pace with the growing demands being made on them..... We are undertaking a thorough-going programme of reforming our institutions, refurbishing them, bringing them up-to-date....."

Rajiv was by now at mid-point in his government's five-year term. "In our development process two questions have arisen," he told a conference in 1987. "First, how to overcome the inertia of the past ideas, which have had past success. Development is a flux. It is a process of changing circumstances..... Resisting our oars is drifting backwards..... New challenges need new responses.

"The second question is that economic development does not necessarily lead to greater human fulfilment and satisfaction. We have seen from the experience of many developed countries that dissatisfaction seems to be the engine of development..... Should we not be looking for something deeper, something more, as the engine behind our development process?....

"Every question contains the seeds of an answer, yet every answer germinates seeds of another question. The search continues."

Rajiv's struggle to speed up the pace of change had brought some valuable lessons: "One of the most difficult aspects of forcing the pace of change is maintaining stability during a period of rapid change. The more rapid the change, the more difficult is the task. Resistance to change comes from inertia. Resistance also comes from inhibitions in the mind towards changing traditional modes of thought and action. But, above all, resistance comes from the vested interests who have captured the system to make it serve their ends.

"Overcoming resistance in all its manifestations while keeping the ship of State both on course and on even keel constitutes the litmus test of leadership.

"There can be no doubt that the country can move forward best on the basis of a broad national consensus, provided always that such a consensus does not stand in the way of innovative new ideas and fresh departures. But forging a national consensus is easier said than done. There are formidable obstacles in the way of building such a consensus. Consensus is, of course important for progress. But progress itself must not be stalled in the quest for consensus.

"The key to success lies in an iron determination to overcome vested interests and remove the dead hand of all that is obsolete. There must be a will to succeed. Without the will to succeed, there can be no success. At the same time, firmness in objectives has to be combined with flexibility in approaches."

Rajiv greatly valued the initiative and commitment he saw in the work of voluntary organizations: "*Your achievement is particularly notable because you have not depended on the government for all your resources. You have developed on your own steam in an imaginative and innovative manner,*" he said to one of the many groups with whom his government was evolving a working partnership. "*A vibrant, healthy democracy needs lots of institutions which can stand on their own feet, each one reaching out for excellence in their areas.*"

"*We have involved voluntary organizations in many of our government initiatives. We have taken their views, sometimes we have adopted their papers almost in toto,*" Rajiv said. He was particularly appreciative of those who worked for the disabled and deprived. The photographs on this page record his visit to Calcutta in January 1987 to the Spastics Society of Eastern India, and a meeting in New Delhi with Mother Teresa.

"Why was it that we could launch a satellite and make rockets, but we could not give drinking water? We found it was not a lack of technology, it was a lack of being able to apply that technology at the right point. The system wasn't working and that's where the Technology Missions came in," Rajiv said. These were innovative models for managing development. As Rajiv envisaged it, the Mission concept approached specific areas with specific targets; its methodology was to "mesh the work of the highest scientific talent with the efficiency expected of the ordinary technician. Thus, the drinking water mission marries the remote sensing of aquifers with the plumber, the mason and the electrician who are required to install, operate and maintain a hand pump," he explained. The challenge, as he saw it, was to break the "routine departmental" mould and inspire each task force with a sense of mission to effectively pilot each project through all the complicated administrative channels.

The photograph of Rajiv inspecting a newly constructed water facility was taken in June 1987 on a tour of Gujarat.

(Facing page, above and centre) In Sri Lanka, ethnic strife between the Sinhala majority and the Tamil minority had caused great suffering and loss of life. India's interests and those of South Asia were at stake. On 29 July 1987, Rajiv and President Jayawardene signed the Indo-Sri Lanka Agreement which sought to meet the Tamil demands in the framework of Sri Lanka's unity.

Speaking in Madras a few days later, Rajiv said: "This agreement not only brings to an end the conflict, it also brings peace, it gives justice to the minority communities in Sri Lanka and it also removes opportunities for hostile forces to destabilize the region. It strengthens the security of our region, it strengthens non-alignment. This is not the time for recriminations or reprisals. This is the time to stop fighting, to stop

started eating the crop," he said in his Congress Centenary speech. Regulations and procedures had bred corruption, inefficiency and vested interests. The innate dynamism and enterprise of the Indian people had to be given rein, he felt, to promote the creation of wealth and jobs. This would in turn generate surpluses to tackle issues of poverty and social justice.

Throughout his years as Prime Minister, Rajiv personally supervised the making and implementation of economic policy, keeping a close watch on performance. In 1987 he had temporarily taken charge of the Finance Ministry. The

photograph above, left, shows him in his Parliament House office for the traditional pre-Budget picture session.

Rajiv believed that global relationships were increasingly moving from an era of military domination to one of economic domination. "If India is not able to cope and survive in a very tough economic global environment, our independence will be threatened." He felt it was imperative for the country to hold its own in competitive markets: "We must match our international economic strength to our international political influence and standing."

A major obstacle to progress, in his view, was the system of bureaucratic controls that had come to gain a stranglehold on economic activity. "The fence has

124

violence and to stop the conflict. This is the time to bring peace, to rebuild and to develop a new friendship between the various communities in Sri Lanka."

The Agreement aroused resentment among a section of the Sinhala community. On 30 July in Colombo, when Rajiv was inspecting a farewell Guard of Honour, a naval rating stepped out and struck him with his rifle butt. Rajiv sensed the blow and ducked. It barely missed his head but he took its full force on his left shoulder.

It all happened so suddenly that few people present were aware of what had occurred. Rajiv continued with the ceremonial function (the formal photograph on the right, centre, was taken minutes later), and was attended to only when we were air-borne. For a very long time after he could not move the shoulder freely or sleep on his left side.

The Indian Peace Keeping Force (IPKF) was later sent to Sri Lanka, at the request of the Sri Lankan government, who were pressed by another extremist insurrection in the south. But, Rajiv said, *"It is a matter of great regret that the LTTE [the Liberation Tigers of Tamil Eelam] threw all this away. They went back on every commitment they had given to us. They deliberately set out to wreck the Agreement, because they were unable or unwilling to make the transition from militancy to the democratic political process."*

What was to be a peaceful transition soon turned into a two-year confrontation between the IPKF and the LTTE.

The morale and welfare of India's soldiers, sailors and airmen were dear to Rajiv's heart. He was with them in spirit in the difficult task they had to fulfil, often in inhospitable terrain or climate. He often expressed his great pride in the Armed Forces. He enjoyed meeting them and their families, chatting with them, sharing their enthusiasm and their concerns. The picture on the right shows Rajiv at the commissioning of *INS Viraat*, India's second aircraft carrier, on 21 August 1987.

Rajiv was to describe the drought of 1987-88 as the major challenge of his prime ministership. He set up a Cabinet Committee, formulated an Action Plan and held regular meetings with the state governments concerned. He travelled across the country for on-the-spot inspections and kept in close contact with district and local officials responsible for relief and development work. He examined weekly progress reports and ensured that the central and state governments, from the Chief Ministers to the village level workers, all worked smoothly and effectively. (The photographs show him in September 1987 touring drought-stricken parts of Gujarat, Rajasthan, Tamil Nadu and a flood-affected area of Assam.)

Rajiv reported to Parliament on some of these measures: "*Using the foodgrains from the buffer stocks, we have launched programmes to generate employment and to build assets to cushion against future droughts.... We have ensured that expenditure on relief became expenditure on development. We have rushed fodder from areas of surplus to areas of scarcity. We have introduced special programmes for drinking water.*"

Because of Rajiv's dedication and meticulous planning, a drought affecting 285 million people and 168 million cattle was successfully managed. The country did not have to import foodgrains, and for the first time ever emerged from a nation-wide drought with a positive rate of growth.

In October 1987, Rajiv attended the Commonwealth Heads of Government Meeting in Vancouver. On his way back, he strongly put forward a Third World viewpoint on environmental issues to the UN General Assembly: "*Programmes of conservation must address themselves to inequities in the international economic order. The average citizen of the industrialized countries consumes ten times more fossil fuels and minerals than the average citizen of the developing world. The world's resources just cannot sustain such profligate consumption of energy and materials.*

"*Neither can developing countries be denied the right to develop, nor are the world's natural resources sufficient for all to follow the greedy path to growth.*" To be effective, he stressed, conservation must be humane: "*The answer lies in more rational patterns of consumption, more efficient utilization of depletable resources by the developed countries, and more equitable access to these resources for developing countries.*

"*The international community must also address itself to safety measures in high-risk industries,*" he pointed out, referring to the disasters in Bhopal, Seveso and Chernobyl.

The photograph shows Rajiv officially opening UNICEF House in New York with Prime Minister Brundtland of Norway, whose environmental report *Our Common Future* he had commended in his speech.

The SAARC summit of 1987 was held in November in Kathmandu. Several leaders present spoke about the problems of ecological degradation they faced. Rajiv drew attention to the need for co-operation in solving ecological problems, saying: "*In our region, as elsewhere in the world, development is the chief casualty of degradation and disruption of ecological systems. Often, neither the causes nor the consequences are confined to national boundaries. Therefore, suitable measures of regional co-operation are required to supplement national action.*"

The Bhopal gas tragedy, in which thousands lost their lives, had occurred when Rajiv was campaigning for the 1984 elections. He had broken off from his schedule and flown to Bhopal as soon as he heard the news. His government took immediate steps to provide all possible relief. It pursued the case vigorously through the courts to establish the responsibility of the multi-national concern. Rajiv is seen listening to the survivors during a visit to some of the rehabilitation centres in December 1987.

From the beginning of his term, Rajiv's energies had been directed at reviving the country's economy and rejuvenating its polity. He was concerned at the absence of democracy at the grassroots, the absence of people's participation in development programmes: "*I found that when I tried to change the system, to push the system to deliver, I came up against blocs, vested interests, which just wouldn't let go. The basic problem I found was that our democratic process had not seeped down far enough. Every time I thought I had identified a solution, that I could convince the people who are facing the problem that, yes, there was a solution that could work, I couldn't convince those at higher levels who had lost contact with the grassroots, whether in politics or in the administration. We worked at opening up the economy to involve more people in the development process, in the building of our nation. At every step we found there was somebody telling us that this was all wrong and shouldn't be done. We found that he had enough friends in the system to block it, even if the policy decisions went through Cabinet. Even when we got it through Parliament, we found that at the real life level, at the interface point, it didn't work because they were just not interested in allowing things to change. So, we have taken this head-on.*"

129

Some of these pictures were taken at home, others in the Lakshadweep islands where we spent some days at the end of the year. The one of Rajiv and myself in the water was taken by Priyanka. As Rajiv got more and more involved in his work and as I was frequently touring with him, the children saw much less of us. This was the only time when Rahul and Priyanka could have their father to themselves.

They spent the day swimming, snorkeling or just relaxing on the beach together. Rahul and Rajiv went scuba diving for the first time. Rajiv attended to his files and other work every day, normally in the evenings.

"Our elders got us freedom and entrusted us with the responsibility of safeguarding and maintaining that freedom," Rajiv often emphasized. Celebrations to mark the 40th anniversary of India's Independence in 1987 merged with the year-long commemoration of Jawaharlal Nehru's birth centenary in 1989.

"Over half of our population is below 40 years of age – less than the years of India's Independence. Hence, it is all the more necessary that this spirit, the spirit which permeated the battle for freedom... should once again be propagated among the present generation," Rajiv said, flagging off the Freedom Run in February 1988.
On 12 March 1988, on the 58th anniversary of the Dandi salt march (padayatra), Rajiv retraced Mahatma Gandhi's steps in the hope that "the spirit of Gandhiji, the same values of truth and ahimsa [non-violence] will reach the youth of today, the values by which Gandhiji lived and for which he laid down his life." The pictures show him paying tribute to the Mahatma and greeting six of the twelve surviving freedom fighters who had walked with Gandhiji on that historic march.

(Below, left) The picture shows Rajiv administering polio drops to a child on World Health Day, 27 February 1988. The Technology Mission on Immunization had been named after his mother: "[She] was fond of a moving line of the poet Rabindranath Tagore who said that each child that is born is a reminder that God has not lost hope in man. Are we doing enough to justify that hope? How many millions of children die in the cradle not reaching even their first birthday?"

(Facing page, above) Rajiv paid special attention to India's relations with the economic and technological leaders of the world. In June 1988, he visited Germany (the picture shows him with Chancellor Kohl). Rajiv welcomed the large number of new collaborations between India and Germany: "The prospects are bright for mutually beneficial cooperation between our countries. On the other hand, the widening

132

trade imbalance between us is a matter of grave concern." He urged the developed world to recognize the need for a new international order: *"The North-South dialogue has ground to a standstill. Growth in most developing countries is in jeopardy. Stability in the developed countries is clouded in uncertainty."*

Going on to the UN, Rajiv presented a major international initiative — a concrete Action Plan for ushering in a Nuclear Weapon-Free and Non-Violent World Order: *"History is full of such prejudices paraded as iron laws: that men are superior to women; that the white races are superior to the coloured; that colonialism is a civilizing mission; that those who possess nuclear weapons are responsible powers and those who do not are not."* He had spent long hours in discussion with eminent scientists and specialists, both Indian and foreign, before drafting the plan. It was a three-stage programme for nuclear and general disarmament by the year 2010, together with measures to institute a new world order anchored in non-violence.

Rajiv's tours also demonstrated to him how urgently India's municipalities needed improvement and modernization; by the end of the 20th century, one in three Indians would be living in towns and cities: *"Impulses for the generation of wealth, income and employment are strongest in the urban centres. The best educated, the young men and women with… enthusiasm, enterprise, zeal and ambition are migrating in droves from rural to urban India."* But the urban systems had not kept pace, and were unequipped with basic amenities: *"A structure conceived in Imperial times for a relatively tiny urban population… has persisted through four decades of freedom."* He saw the need for comprehensive legislation to acknowledge the reality of the country's changing demographic profile. This was the nucleus of the Nagarpalika [Municipalities] Bill with which Rajiv sought to reform the basis of urban planning and organization. He is seen visiting a suburb of the capital after a cholera outbreak in June 1988.

Secularism was for Rajiv an inherent and passionately held belief, and he saw it as intrinsic to the philosophy of non-violence. He cherished his country as a society "*where diverse faiths, languages and cultures can live together in harmony*". The secularism that he championed was not anti-religious or irreligious, but one that respected all forms of spirituality: "*That rich vein of spirituality is the source of our moral values, of our ideals and our standards... Religion has high value but must remain in the sphere of private and personal life. It has no role to play in the politics of the country.*" Rajiv honoured faith wherever it was expressed; the pictures on this page show him in August 1988, visiting a temple, a mosque and a church in Tamil Nadu.

Rajiv saw secularism as the core of India's unity: "*In the midst of bloodshed and communal passion the founders of the Indian State repudiated the false, perverse and basically inhuman doctrine of communalism,*" he had told a group of teachers and professors in September 1987. "*There are political and religious organizations which continuously foment fear, insecurity and separatist views... In other words, while the Constitution, the law, the formal political structure point in one direction, elements of social consciousness point in another.*"

Rajiv stressed the need for a social and political movement to uphold secular values: "*To my mind, the resurgence of communalism is the biggest challenge to national unity.*"

Rajiv persevered with his leadership task of exhorting and inspiring his party. At the Congress Party meeting in Maraimalainagar, he said: "*We, who are the inheritors of its great traditions, owe it to those who bequeathed it to us to keep it vibrant and alive, dedicated to the service of the Indian people.... We must ask, as many Indians are asking, why is it that with all the talent we have in this country, with the tremendous ability and energies of our people, we don't seem to be able to get things to work properly?... It is true we are doing well, better than we have done before. But we have recorded these achievements in spite of our muddling through, all too often pulling in different directions. We have millions of young men and women with high ideals and higher hopes emerging each year on the threshold of adulthood only to fall back in frustration, defeated by the cynicism of the system.*

"*We must be alert and responsive. We must shape our Party so that it is able to reflect the aspirations of the people. It is not easy for such a vast organization rooted in past habits to make a fresh move. It is still more difficult for an organization which has attained success to keep alive to change and growth. Oddly enough, nothing is more dangerous in a way than to succeed, for this leads one to think that our work is over. Our work is far from over.*"

Rajiv was the first Indian Prime Minister to go to China since his grandfather in 1954. His visit marked a historic breakthrough for regional and world peace. Both countries were able to secure peace and tranquillity in the border areas.

A joint working group was set up for a fair and reasonable settlement of the boundary question. The world's two most populous countries, sealed off from each other for a quarter of a century, began anew to explore economic, scientific and technological co-operation and exchanges, and to consult each other on various international issues. The picture below shows Rajiv in Beijing with China's Chairman Deng Xiaoping in December 1988.

"Experience has shown us that economic transformation can be engineered without massive upheavals and discontinuities only through a political system in which the poor are able to exercise political power through the dominant influence of their vote. There is, therefore, a symbiotic relationship between what Panditji called 'political democracy' and 'economic democracy'. It is this symbiotic relationship which is at the core of our development policies.

"Mahatma Gandhi had stressed that democracy would be meaningful to the vast millions of our people only if it were based on village panchayats – the ancient village republics of India. In 1959, Jawaharlal Nehru launched Panchayati Raj in rural India as a great revolutionary measure to systemically transform the Indian polity.

"...There is no substitute for a locally elected authority, representative of the people, accountable to the people, and responsive to their needs. The answer to these problems does not lie... in making some change here or some adjustment there, some improvement here or some correction there. The system itself has to be changed," Rajiv said in his Nehru Memorial Centenary lecture in 1989.

The Panchayati Raj and Nagarpalika Bills were Rajiv's answer to the issues he had raised in his first broadcast to the nation, and in his Congress Centenary speech. "I must confess, we were in quest of managerial solutions to unresponsive administration," he said in Parliament, referring to the first stage of his quest. "What was needed was a systemic solution."

"After Independence, we had promised in the Constitution to strengthen the third level of our democracy," he explained. This had not happened. "The institutions of Panchayati Raj have lacked strength and vitality precisely because they have lacked Constitutional safeguards."

"Putting together both Houses of Parliament and all the State Legislatures, we have only about 5,000 to 6,000 persons representing a population of nearly 800 million," he pointed out. As a result, "This gap has been occupied by the power-brokers, the middlemen, the vested interests. For the minutest municipal function, the people have had to run around finding persons with the right connections who would intercede for them with the distant sources of power." The Bill he proposed would correct this imbalance: "The people's stake in democracy will be increased by a factor of approximately one hundred and fifteen." Their initiative and their talents would be awakened in the process of taking the responsibility for their own lives, and a tremendous reservoir of potential leadership would be activated.

Rajiv presented the Panchayati Raj Bill to Parliament after two years of intensive discussions and consultations at all levels of the bureaucratic and political authority. "We have come to this House at the culmination of a process of open, transparent consultation without precedent in the history of independent India," he said.

The Opposition tried to trivialize the Bills as election gimmicks. Rajiv answered them with dignity: "We are making democracy at the grassroots a solemn and ineluctable Constitutional obligation.... An election gimmick is a trick of the trade. A Constitutional Amendment is a solemn, long-term pledge. Ours is a pledge to the people."

(The photographs on pages 136 – 140 are of Rajiv's state assembly election tour in Tamil Nadu in early 1989.)

"There is no problem before the country so acute as the problem of unemployment and under-employment," Rajiv said in Parliament in April 1989. He was launching the Jawahar Rozgar Yojana, a programme of massive employment meant to benefit 44 million families living below the poverty line. It absorbed and expanded on existing programmes, and the funds for employment schemes were to be channelled to recipients through the panchayats, village councils, bypassing the customary chain of bureaucracy.

"We also expect the implementation of the programme to be more open, more transparent than ever before. Every villager will know how much money is available for the programme and which are the schemes being financed.... Those who are cheated or deprived will not only have the possibility of demanding immediate redress, they will also have in their hands the ultimate weapon of the vote to turn out of office any Panch or Sarpanch who abuses the powers and responsibilities devolved on him. Democracy will reinforce opportunities to bring the Welfare State to the doorstep of the villager, where he lives and seeks work."

"In every segment, class or community, women suffer all the disabilities inflicted on that group and, in addition, suffer also the consequences of gender discrimination. Yet, their contribution to economic life, social well-being, cultural continuity and ethical standards is far greater than their share of the population," Rajiv said.

His government increased the financial allocation to the Department of Women and Child Development three-fold in five years. He sponsored the National Perspective Plan for Women and outlined the Indira Mahila Yojana, a comprehensive programme for women and children. Programmes relating to women's employment, education and welfare would be implemented with the active involvement of voluntary organizations in the field and, most important, of the beneficiaries themselves.

"We, in India, are the inheritors of a great historical experience in organizing a multi-lingual, multi-ethnic, multi-religious, multi-caste, multi-regional society. The global village of the new technology has to learn from our experience the basic lesson of how humanity is to live together, not in segregated states but as one human family."

"The idea of India has not only risen above passing political divisions, it has also risen above the racial, linguistic, cultural and religious diversity of the people. Every ethnic group, howsoever defined, deeply believes – and with confidence asserts – that it is part of the larger entity called India."

"Equally, each ethnic group, ranging from overwhelming religious majorities like the Hindus to numerically small minorities like the Zoroastrians, finds it natural to coexist with the other ethnic groups.

"From time to time through our history there have been attempts to build on narrower identities. But such attempts have not endured. In the long run, the larger idea of India has marginalized those who, in political terms, have attempted to build themselves on narrow identities."

"We are one nation and not a union of nations precisely because our nation has room for all manner of diversity. By preserving and promoting all our cultures, we have evolved a composite culture. By transcending ethnic identities without dissolving them, we have created a higher loyalty to the nation, preventing ethnic, linguistic, religious or regional differences from consolidating themselves into divisive political boundaries."

Analyzing India's population problem, Rajiv explained why he thought the intervention of official agencies did not seem to be effective. The data on population growth showed immense variations not only from state to state but from district to district. "*Yet, to a very large extent, our family planning programmes are more or less uniform throughout the country.*" It was the same conceptual gap as he had found in other areas of development, between the planning authorities and the reality on the ground: "*Successful family planning is such an intensely personal, private matter that Government agencies can, at best, contribute to raising awareness, creating an ethos and making available the required supplies.*" He suggested that the programme be decentralized and integrated with other development programmes: "*I would hazard the prophecy that a delivery system run and supervised by the poor, deprived and largely illiterate people of India will prove far more effective than the paternalistic model... we have relied upon so far.*"

"*Panditji's vision of India encompassed our millenial past and looked out to a millenial future,*" Rajiv said.

"*Our true celebration of the birth centenary of Pandit Jawaharlal Nehru would lie in building a kinder India in a kinder world, a strong and stable India, an India without poverty, an India which is just and humane, an India in which knowledge flourishes and wisdom is respected, a secular India which is above all narrow parochialisms, an India in which all the weaker sections of today – the Scheduled Castes and the Scheduled Tribes, the other backward classes, the minorities, women, youth – are all assured equal opportunity and a life of fulfillment.*"

Celebrations across the country in 1989 commemorated the life and vision of one of its great architects. The photograph below shows Rajiv participating in the Jawaharlal Nehru Centenary Run in New Delhi in March. In the picture above, a mother hands Rajiv her infant to name. (This was a frequent occurrence in his tours around the country.)

The annual convocation at Visva-Bharati at Santiniketan was an event Rajiv, as Chancellor of the University, never missed. It had been founded by the great humanist poet Rabindranath Tagore, and Rajiv's mother had been a student there. The picture shows Rajiv before a sculpture by the renowned sculptor of Bengal, Ramkinkar.

Communication and information technology was central to Rajiv's vision of 21st century India. Quick and effective decision-making, he felt, could not be on the basis of conjecture but depended on accurate information and relevant analysis. Rajiv used computers extensively for this purpose, in his political work and for his own time and task management. While he was away from his office, news and messages flowed between him and his staff in Delhi on his lap-top computer.

During Rajiv's tenure as Prime Minister, he succeeded in getting most government departments computerized at central and state levels. He felt this would improve productivity and cut down on red tape and malfunctioning.

Manual procedures of organizing information had allowed vested interests to accumulate power; there was thus a great reluctance on their part to adopt these systems. But Rajiv was determined to place India in the front ranks of the new information technology.

In spite of a long history of disputes and confrontation, Indo-Pakistan relations improved considerably during Rajiv's prime ministership. He welcomed President Zia-ul-Haq in India several times and visited Pakistan thrice. The photograph of him and Pakistan's Prime Minister Benazir Bhutto was taken at a press conference during his state visit to Pakistan in July 1989.

However, when it came to defending India's interests, Rajiv was uncompromising. He denounced Pakistan's clandestine support to terrorists in Punjab and Kashmir, and exposed its secret nuclear programme.

Through his years as Congress President, Rajiv wrestled with the problem of party reform and reorganization. In 1990 the Congress Working Committee (right, above) finalized a schedule for the party elections. Rajiv authored amendments to the party constitution ensuring representation to the rural areas and preventing further postponement of the election beyond 1991-92. The schedule was ratified in January 1991, but because of the general elections it was not until 1992 that the Congress Party organizational elections could be held.

The photograph right, centre shows Rajiv delivering his last address to the nation on Independence Day.

The photograph right, below of Rajiv conferring with President Julius Nyerere of Tanzania was taken in Belgrade at the ninth Non-Aligned summit in September 1989. He rallied his colleagues in the Movement to what he saw as their new task in the era following detente: to strive for a new world order. "*We concerted our efforts against colonial, political and military domination.... Equally must we concert our efforts against economic domination....*

"*Multilateral institutions for international co-operation are being weakened or ignored. In the guise of economic groupings, there is a resurgence of economic regionalism.*" He pointed to the "*protectionist and discriminatory trade practices*" of the developed countries, and urged a renewal of the North-South dialogue: "*Let these groupings not become new blocs of trade wars and global economic confrontation.*"

"*It is we who suffer most the consequences of the structural imbalances which afflict the world economy. We must be party, therefore, to decisions which affect the world economy.*"

It was at this meeting that Rajiv proposed a Planet Protection Fund, with a view to financing both research and distribution of "*environmentally safe and friendly technologies*". He pointed out that just one-thousandth of the Gross Domestic Product of all participating countries would raise a corpus of 18 billion dollars for such a Fund.

143

The 1989 election was scheduled for November. In October the Panchayati Raj and Nagarpalika Bills had been passed in the Lok Sabha but defeated in the Upper House, the Rajya Sabha. Rajiv campaigned on the strength of his government's record of the past five years and its programme for the future. The Opposition parties, cutting across ideological and political differences, came together in most constituencies to field common candidates against the Congress, to prevent the non-Congress vote from getting divided.

As always, Rajiv did not spare himself during the strenuous month-long campaign. Apart from two brief visits to Amethi, he left his campaign in Amethi to Priyanka and me, while Rahul accompanied him on his tour.

Polling took place on 22 and 24 November, 1989 and the results were declared by 28 November. Rajiv was re-elected as the Member of Parliament from Amethi. The Congress Party won 197 seats of 517 contested, making it the single largest party in Parliament, but it was short of a majority.

On 29 November 1989, five years and one month after he first became Prime Minister, Rajiv sent his resignation to the President. In his broadcast to the nation that evening, he said: "*Elections are won and lost. The work of a nation never ends. We shall not falter in our resolve to do our duty by India.... With all my strength, I shall continue to serve the people of India.*"

He was unanimously elected leader of the Congress Parliamentary Party, and was recognized as Leader of the Opposition.

Rajiv no longer carried the burden of the country's highest executive office, but events were soon to draw him to the same intensity of political activity. He was carrying out numerous responsibilities as a Member of Parliament, as Leader of the Opposition and as Congress President. The stream of visitors never abated.

Conscious of the vital need to examine his party's performance in the 1989 election, he engaged in detailed analysis with his party colleagues and workers. He believed that several causes had contributed to his party's reverses; the most important he identified some months later in an interview: "*I do feel that our government had many achievements. The country did better in almost every sphere than it had done ever before, but still there was a perception that not enough was being done. We were not able to communicate to the people, and in some areas I think the people were not able to communicate to us. And this I think is the biggest problem which needs to be addressed.*"

The inherent weaknesses of the National Front alliance very soon became apparent. Crisis followed upon crisis, sectarian conflicts flared up and, as a Congress Working Committee resolution on Kashmir pointed out, "*for the first time in the history of free India it [was] the terrorist and the secessionist who [controlled] the pace of events.*" Over the next year, in Kashmir and Punjab, in Assam and in Tamil Nadu, forces intent on breaking the Indian Union were allowed to gain the upper hand.

Rajiv described the Kashmir crisis to Parliament "*as about the gravest the nation has faced in 42 years*" of Independence: "*Kashmir is fundamental to our civilization, it is fundamental to our secularism, it is fundamental to our nationhood today.*" He visited Srinagar with an all-party delegation and offered the government his party's full cooperation. The picture shows him leading a delegation of Members of Parliament to meet the President on the Kashmir issue on 29 March 1990.

Rajiv was deeply concerned at what was happening in the country. Wherever trouble broke out or natural disaster struck, he would be there to comfort and to help. By August 1990, the country was in turmoil. As a result of a sudden decision of the government to partially implement the Mandal Commission report on reservations, young people came out in large numbers to protest, and many tragically immolated themselves. The Congress condemned the "*precipitate, ill-considered and irresponsible*" decision that had "*plunged the country into a caste war*". In a resolution, it said: "*The evil of caste and caste-based discrimination has plagued our society and our civilization for centuries. It was with a view to ridding our nation of this evil that our Constitution pledged equality and fraternity to all our citizens and proclaimed the abolition of all discrimination based on caste.*

"*The founding fathers of the Constitution deliberately used the word 'classes' and not 'castes' because they were fully conscious of all the many dimensions of backwardness.... It was no part of their purpose to perpetuate caste divisions, caste consciousness or even caste awareness in our society.*"

(The photographs show Rajiv in Meham, where there had been political violence in May; in Panwari near Agra with victims of caste violence in June; and in Bijnor with victims of communal violence in November.)

The experience of leadership over five years had deepened Rajiv's understanding of how his vision for India would be realized. In 1985 as a young leader he had challenged the status quo single-handedly; thereafter his task had been to mobilize his party followers and inspire his countrymen to share his vision. "*India is strengthened by our different languages and castes, our religions and our controversies,*" he had often said. But, he also stressed, "*If we turn this diversity to divisive ends, we become very quickly debilitated.*"

That rapid decline was now overtaking the country, and it was imperative for Rajiv to carry to the people the message of harmony and unity. This page records some of his numerous tours through 1990. He was on the move again, travelling much of the time by train (photographs above).

In Rajiv's speech at the Congress Centenary celebration five years earlier, he had offered a perceptive analysis of the politics of the opposition parties: "*They have shown a cynical disregard for sensitive issues of national security. Some have not hesitated even to collude with anti-national elements. Their ideological roots are shallow, their political outlook circumscribed by region, caste and religion. Wherever they have come to power, they have retarded social and economic progress. They have no sense of history.*"

An atmosphere of fear and suspicion had been created between religious groups, and communal tensions were increasing. On 10 May, the anniversary of the 1857 Meerut uprising which had sparked off India's first War of Independence, Rajiv led a symbolic one-day fast at Raj Ghat.

In October, Rajiv set out on a Sadbhavana Yatra [Pilgrimage of Goodwill] to promote amity and harmony between communities. Starting from Raj Ghat (photograph on facing page) on 2 October, Gandhiji's birth anniversary, the procession wound through the streets of the old city; it took us almost 7 hours to cover 10 kms through dense crowds.

Rajiv's Sadbhavana Yatra continued (photograph below) and touched a number of places where strife had broken out between communities. It was to go all the way to Assam, but was overtaken by events: on 7 November 1990, less than a year after taking office, the National Front government fell after losing a confidence motion in the Lok Sabha.

On 16 October 1990, Rajiv had welcomed Nelson Mandela on his arrival in New Delhi to deliver the year's Nehru Memorial Lecture. In his welcome address, Rajiv said: "*The freedom of India started in South Africa, and our freedom will not be complete till South Africa is free.*"

He had first met Mandela in Windhoek. When the news came that Namibia had won its independence, it was for Rajiv as if a life-long wish had come true. He was overjoyed when he received an invitation from President Sam Nujoma to participate in the celebrations in Windhoek. At midnight on 20 March, when the flag of Namibia was unfurled, Rajiv felt the jubilation and excitement of a free new nation. He came back full of that moving and historic moment. He had been touched by the emotion his grandfather and his parents must have experienced in 1947 when the people of India felt and voiced their freedom.

A new government was sworn in, with the Congress Party supporting it from the outside. The President had invited Rajiv to form the government, and he had declined. Only when the people of the country gave him a clear mandate would he accept office. The picture above shows him at Rashtrapati Bhavan after a meeting with the President on 8 November 1990.

On 6 March 1991, the government resigned. In an interview, Rajiv said: "*There seems to be a feeling that we are the ones who precipitated the resignation of the Government. At no time did we withdraw support.*" The Lok Sabha was dissolved on 13 March and within a few days Rajiv was once again caught up in a hectic programme of tours.

"*The Congress was the first political party in India to categorically condemn Iraq's invasion of Kuwait,*" Rajiv was to say in an interview. But he felt strongly that the Western allies had not done enough to find a peaceful solution: "*Surely at the end of the 20th century, war is not the answer to problems!*" At a party meeting in early February, he expressed his anguish at the carpet bombing of Iraq. In the heat of the crisis, he was invited to visit Moscow and Teheran to confer with the leaders of the two countries about the grave dangers to the world community arising from the war in West Asia.

Through January and February, Rajiv was mostly engaged in consultations with his colleagues on the economic and international situations. Closer to the elections, the meetings became even longer and more intense, especially when it came to selecting candidates. Often he would be working through the night. It was a precursor of what was to come in the electoral campaign. The picture below shows Rajiv at a meeting in his study with some of his senior party colleagues.

We moved to our new house, 10 Janpath, on 5 February 1990. The photograph of Rajiv with the dogs was taken in Mehrauli at the end of December 1990. It was the only time we ever stayed in our farm-house. For the few days we were there, Rajiv occupied himself with organizing the house and the garden, and occasionally preparing snacks, which he much preferred to a proper meal.

The photograph next to it is an earlier one, taken by my sister during Holi in 1988. This festival was for Rajiv an occasion for much light-hearted fun. He would play at colours with his colleagues and members of his staff, and the children would join in.

Rajiv took the picture of Rahul and myself on 19 June 1990, Rahul's birthday and the day he left home to study abroad. The pictures of Priyanka with Rajiv and of myself with Rajiv were taken in March 1991 by Christian, the old friend through whom Rajiv and I had met in Cambridge.

151

The Congress Party's manifesto represented Rajiv's agenda for India and his promise to the electorate. Work on the party's policies for the future had begun in 1990, when Rajiv put together panels of experts and with them analyzed and planned out in careful detail what needed to be done. In March and April 1991, he devoted a great deal of time to finalizing the manifesto, working on each section with meticulous attention. The result was a comprehensive document spelling out in detail the measures a Congress government would take to meet its targets within specific time frames. The photograph above was taken in March 1991 in Bhopal, the one below in early April on what was to be Rajiv's last visit to Amethi.

In early April, the Election Commission announced that the elections would be held on 20, 23 and 26 May. On 24 April, Rajiv and I went to Sultanpur,

the district headquarters, where he filed his nomination for Amethi (photographs on facing page). On 28 April I left for his constituency where I remained until 17 May.

Rajiv knew of the great danger to which he was exposed from diverse terrorist groups. He knew very well that the security cover provided to him was nominal. But he was never one to allow considerations of personal safety to deter him from his mission. His country was threatened as never before by discord, disorder and drift. It was his task to lead his party in the electoral battle. On 1 May, Rajiv started on his election campaign.

In many of the photographs of the campaign in the following pages (154 – 157), Sub-Inspector Pradip Kumar Gupta can be seen — the loyal and brave Personal Security Officer who died by Rajiv's side.

Rajiv put his heart and soul into his campaign. There were days when he would use a plane and helicopter to cover long stretches and reach distant parts of the country. On other days, he would drive long distances by car, addressing scores of formal and informal meetings, mobbed by well-wishers.

They would line the roads to greet him; at every village, every cross-roads, people would rush forward and stop his car. They rejoiced in his presence, their faces glowing with pride and happiness at having him in their midst. They would hand him their little children to bless, they would want to be photographed with him or collect his autograph, or simply come close to him, touch him and give him a hug. A few words and he would be off, tossing back the flowers and garlands he received in abundance. There was much ground to be covered, and not enough time.

Frequently, he would be hours behind schedule, slowed down by the persistence of people reluctant to see him depart. Yet, they would be waiting patiently for him to come, oblivious of the summer heat or the late hour. He addressed packed meetings late at night and early in the morning, and even at 4:00 or 5:00 a.m., thousands of people would wait for his arrival, and give him an overwhelming welcome. They had witnessed the mess all around created by lack of firm and responsible leadership. They were looking forward to his return as their leader.

Often, one day's programme would slip without break into the next, and he would rest by closing his eyes for brief intervals in the car or the helicopter. It would soon be time for the next meeting, and he would be fresh and wide awake. He would usually pilot the light plane he used. Although the long hours and pressure took their toll, he campaigned tirelessly and cheerfully. For a few days in the middle of the tour, the strain on his throat caused him acute discomfort and he was not able to speak easily. But at no time did he cancel a meeting or skip an engagement.

155

On 20 May, Rajiv returned to Delhi to cast his vote, and soon after left for a tour of western Uttar Pradesh. His campaign had taken him 30,000 kilometres through more than 600 parliamentary and assembly constituencies in every region and almost every state of India. It was now drawing to a close; he was to return to Delhi on 22 May for a night halt, and to complete his campaign on the afternoon of 24 May.

Rajiv spent 21 May electioneering in the states of Orissa, Andhra Pradesh and Tamil Nadu. The last public meeting on his route that night was to be at a small town on the road between Madras and Kanchipuram.

On 21 May 1991 at 10:20 p.m., Rajiv was killed by a terrorist bomb in Sriperumbudur.

On the morning of 22 May, Priyanka and I brought his body back from Madras. We took him home, and from there to Teen Murti House, where he lay in state for two days, in the spot where the bodies of his grandfather and his mother had in turn rested before their last journey.

On 24 May at 5:25 p.m., his cremation rites were performed by our son according to the instructions Rajiv had set down.

On 27 May the ashes from Rajiv's funeral pyre were distributed to every state and immersed in the sacred waters of his beloved country. A special train brought his remains from Delhi to Allahabad, his ancestral home.

On 28 May at 12:50 p.m. they were immersed in the Sangam, the confluence of the Ganga and Jamuna, into which the ashes of his ancestors had been cast.

"It takes much more guts and courage to be non-violent than it takes to be violent."

— Rajiv Gandhi

"True non-violence requires understanding of the historical and moral truth that hate does not drive out hate, that anger cannot conquer anger, that fear does not overwhelm fear. In the heart of a truly non-violent person, there is a profound belief that hate can only be driven out by love, that anger can only be conquered by compassion, and that fear can only be overcome by courage."

— Rajiv Gandhi

EPILOGUE

IMAGES BY RAJIV

Ellora, 1961

Ajanta, 1961

Pushkar, 1976

Pushkar, 1976

Kashmir, 1979

Kashmir, 1979

Pushkar, 1976

Pushkar, 1976

169

Italy, 1979

Place and date unknown

Amit, circa 1982

Italy, 1979

Italy, 1979

Italy, 1981

Jaisalmer, 1981

Jaisalmer, 1981

Italy, 1979

Kashmir, 1979

Italy, circa 1979

Italy, 1979

New Delhi, date unknown

Kashmir, date unknown

Gumbo, date unknown

Bangkok, 1975

New Delhi, date unknown

Kashmir, 1982

Chail, 1982

Corbett National Park, date unknown

Corbett National Park, date unknown

Ranthambhor National Park, 1986

Ranthambhor National Park, 1986

Ranthambhor National Park, 1986

Ranthambhor National Park, 1986

Kanha National Park, 1985

Ranthambhor National Park, 1986

Ranthambhor National Park, 1986

Above and below: Ranthambhor National Park, 1986

Kanha National Park, 1985

Mt Etna, Sicily, 1980

Ladakh, 1985

Ladakh, 1985

Kashmir, 1982

circa 1982

1981

1979

circa 1971

circa 1978

Above: 1971, right: circa 1982, below: 1987

1978

Above: 1979, right: 1982, below: 1987

1966

Above: 1986, centre left: 1975, centre right: 1984, below: 1982

211

Lakshadweep, 1988

Photo Credits

JACKET FRONT: Lord Lichfield (courtesy Koh-i-noor magazine)
JACKET BACK: N.L. Sharma
PRELIMINARY PAGES: Title spread: (a) photographer unknown, (b) P.N. Sharma, (c) photographer unknown, (d) photographer unknown, (e) photographer unknown, (f) Sunil Janah, (g) Disher Singh Virk, (h) Roberta Orecchia, (i) Dilip Mehta/Contact Press Images, (j) Dilip Mehta/Contact Press Images, (k) photographer unknown, (l) Ajit Kumar; Contents: Anup Sood; Facing text: Priyanka Gandhi

OTHER PAGES: Aloke Mitra/Ananda Bazar Group, Calcutta: 91 (above, centre, below); Amitabh Bachchan: 113 (above left, above centre, above right, centre right), 131 above left, centre right); Ananda Bazar Patrika, Calcutta: 98 (centre), 142 (above), 155 (below), 88 (below), 90 (below right); Anouchka Maino Vinci: 76 (centre), 130 (above left, centre left, centre right), 151 (above right); Anup Sood: 23 (below), 25 (above left, above right, below), 79 (below centre); Arun Jetlie: 153 (below); Ashok Nigam: 37 (below); Associated Photo Service, Delhi: 35 (above left, above right & below); Avinash Misra: 151 (above left); Baldev/Sygma: 66 (above left), 136–137, 141 (above); Beech Aircraft Corp, Kansas, USA: 53 (above); Bhaskar Paul: 129 (below), 142 (centre), 156 (above); Bhawan Singh/India Today: 95 (centre), 111 (below), 114, 116, 135 (above), 142 (below), 148 (below); Christian Von Stieglitz: 151 (centre right & below); Devinder Mohan/Photo Division, Govt. of India: 103 centre right), 119 (below); Dilip Mehta/Contact Press Images: 78 (above), 82–83, 84 (centre) 85 (above), 86–87, 87 (right), 88 (above), 89 (above left, above right & below), 92 (below left), 95 above & below), 96 (above), 97; Disher Singh Virk: 54 (above), 57 above left), 60 (above left, above right, below), 61 (above left); Dawn Singh: 113 (second row right, third row left); Dr U.P. Singh: 84 (above) above, below left & below right) 33 (all photographs), 41 (above); Feroze/India/Friends: 21 (all photographs); GP Hutheesing (?): 22 (below); Giorgio Lotti: 122; Gopal Chitra Kuteer, New Delhi: 85 (centre left); Harlip: 19 (left) Hindustan Photo Service, New Delhi: 48 (below); Homai Vyarawalla: 39 (below); India Today: 99 (above); Indira Gandhi Memorial Trust archives: 59 (below), (below); India Photos, New Delhi: 34; Jitendra Arya/Reflex: 38; Julian Rust: 18 (below); Kamal Nain Narang: 147 (above left), 152 (above); Kharak S. Kaira: 155 (above); Kundal Lal, Indian News Chronicle, Delhi: 37 (above); Lalit Gopal: 32; Les Goodey: 56 (above); Lord Lichfield: 98 (above); Lotte Meitner Graf: 43 (above); M. Shylla/Photo Division, Govt. of India: 93 (centre); Mary Anne Fackelman-Miner, The White House: 100 (above); Mela Ram: 48 (above), 49 (above & below); Mohammed Yunus: 42 (right); M.N. Desai: 51 (below); N. Thiagarajan: 55 (below left, below right); Namas Bhojani/India Today: 156

Nehru Memorial Museum & Library archives: 17, 27 (above), 51 (above), 55 (above); Pablo Bartholomew (courtesy Photo Division, Govt. of India): 108 (below); Photo 'Central', Bombay: 30; Photo Division, Govt. of India: 39 (above right), 93 (below), 98 (below), 99 (below), 100 (below), 101 (centre), 102 (above), 103 (below left), 104 (above, centre & below), 106 (above & below), 107 (above & below), 108 (above), 110, 111 (above), 115 (centre & right), 117 (above & below), 119 (above), 121 (centre & below), 124 (above & below), 125 (below), 126 (above & centre), 127 (above & below), 129 (above & below), 132 (centre & below), 134 (above, centre & below), 140 (above); P.K. Kapoor: 115 (above); Pradip Kaul: 58 (above); Pramod Pushkarna/India Today: 143 (centre), 150 (above), 152 (below); Prashant Panjiar/India Today: 118 (above), 121 (above), 143 (above), 154 (above & below), 157, 159, Priyanka Gandhi: 130 (below), 131 (below); Raghu Rai: 90 (above left, above centre, above right); Raghu Rai/India Today: 85 (below right), 96 (centre & below), 144 (centre & below); Raghubir Singh: 112 (above & below); Rajiv Gandhi: 56 (below left & below right), 57 (centre right, above centre left, below left & below right), 63 (centre & below), 67 (above, centre & below), 68 (centre left, below left & right), 69 (above left & right), 70 (left & right), 72 (above & below) 74 (below), 75 (above, centre & below), 76 (below), 113 (below left) 130 (above right), 131 (above right), 151 (centre left) 162–212; R.C. Pande: 77 (below right); Reuter: 125 (above); Saibal Das/India Today: 147 (centre); Sanat Jhaveri & Co, Ahmedabad: 132 (above); Sondeep Shankar: 77 (below left), 82 (left), 90 (below left), 94, 120 (below), 150 (below); Sanjay Gandhi: 63 (above), 68 above left); Shanker: 29 (right & left); Sharad Saxena/India Today: 144 (above), 146 (below), 147 (below); Sharma: 40 (below); Shekhar Raha: 54 (below); Sukhdev Bhachech: 81 (below); S.N. Sinha: 84 (below); Subhash Chander/PTI: 147 (above right), 148 (below), 154 (centre); Sunil Janah: 52; Sunil Kumar Dutt: 123 (below) 153 (above); Parriot, New Delhi: 76 (above); T.S. Ashok: 93 (above); UNICEF/Lily Solmssen: 128 (centre); Usha Bhagat: 43 (below left & right), 45; Valeska: 41 (below left & right).

PHOTOGRAPHERS UNKNOWN: (Prints presented to the family, or part of the family collection): 18 (above left & above right), 20, 24, 25 (below), 26, 27 (below), 31 (left), 31 (right), 36, 39 (above left), 40 (above), 42 (above left & below left), 50 (above & below), 53 (below), 58 (below), 59 (above), 62 (above & below), 64, 65, 66 (below), 71 (above), 73, 74 (above), 77 (above), 78 (below), 79 (above), 85 (below left), 90 (centre right), 92 (below right), 101 (above & below), 102 (below), 103 (above, below left & below right), 105 (above & below), 109 (left, above right & below right), 118 (below), 119 (centre), 123 (above), 125 (centre), 126 (below), 128 (above & below), 133 (above), 135 (below), 138–139, 140 (centre & below), 143 (below), 146 (above right), 149 (above), 161